The Knitted Hat Book
20 Knitted Beanies, Tams, Cloches, and More

INTERWEAVE.
interweave.com

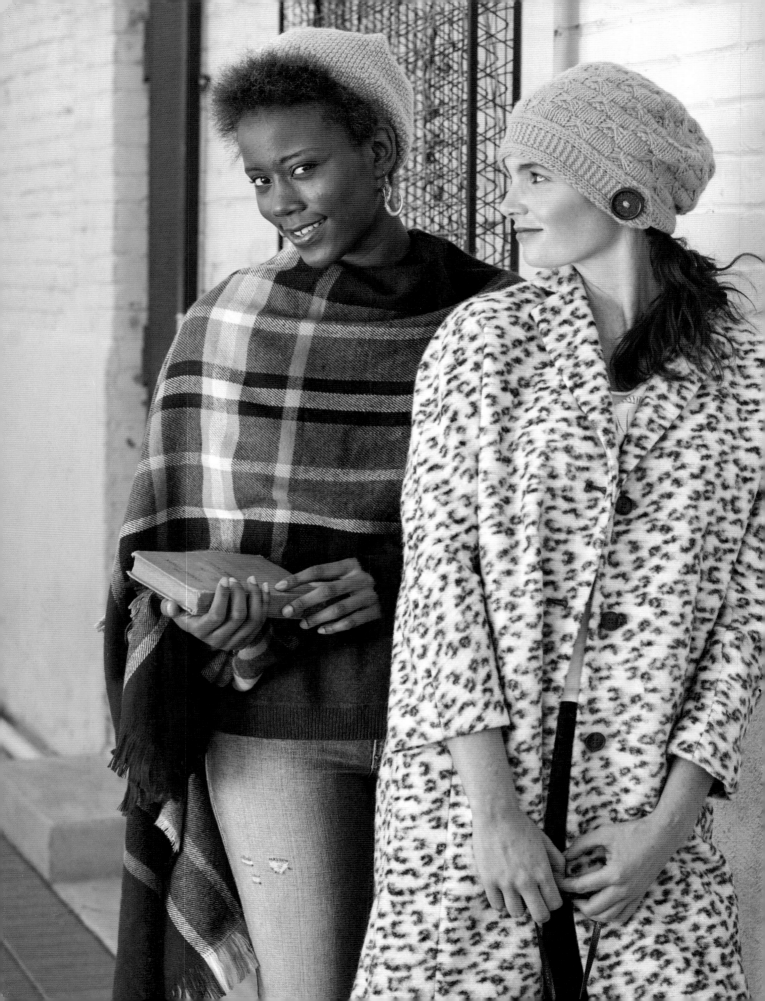

CONTENTS

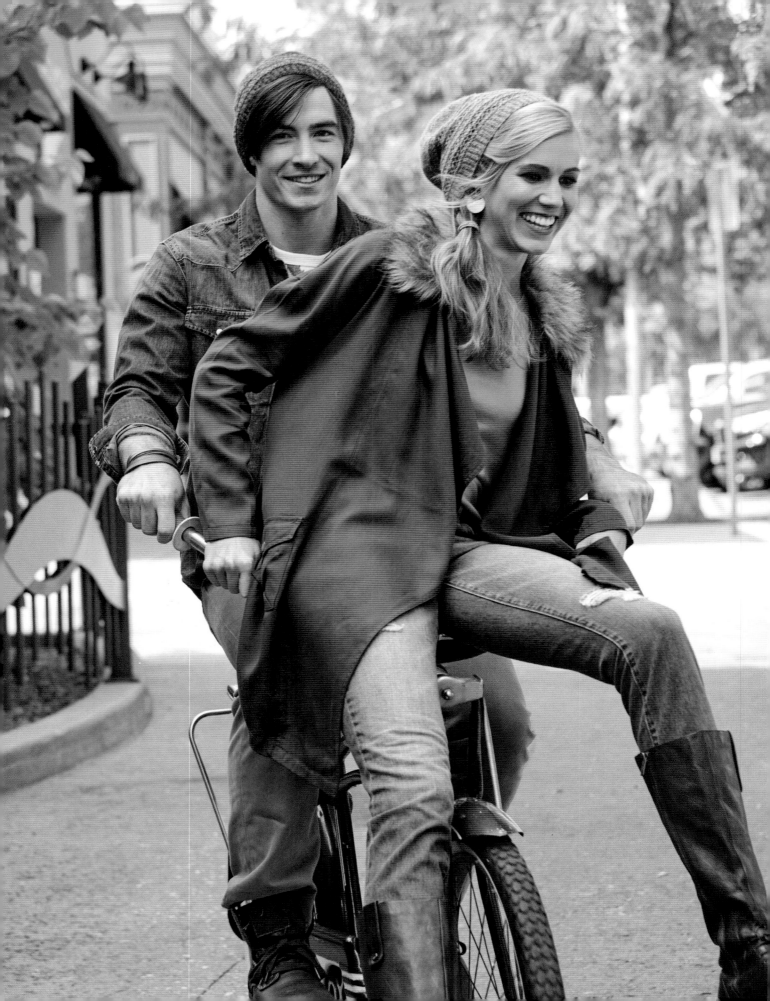

Introduction
Hats Off to Knitting!

You've seen the headlines: Knitted hats are hot! More than just a great way to keep your noggin warm, they provide a dash of color and style and are the perfect way to top off an outfit.

Hats are often one of the first projects a knitter takes on (after a scarf or two!) and remain favorites with more experienced stitchers. There are many reasons why knitters continue to cast on for caps. They're easy to knit on the go. They're ideal small projects for trying out new knitting techniques and patterns. And because they're quick to make, don't use a ton of yarn, and are easier to fit than a sweater, they make great gifts.

We asked our favorite knitwear designers to put on their thinking caps to come up with a fresh collection of irresistible hat patterns. We're head over heels with the designs they came up with. They've covered all the most popular shapes and stitch patterns. Simple beanies come alive in Fair Isle, cables, lace, and slip stitch. Buttons, bows, flowers, and appliqués adorn feminine cloches. Classic berets and tams are given a fresh look with striking stitch patterns. Unusual shapes, such as a tied kerchief and a tasseled paperbag hat, go beyond the basics.

In this diverse assemblage, you'll find head coverings suitable for every season and for all knitting skill levels. Best of all? Many of the designs in this fabulous compilation are suitable for him or her, so everyone is covered.

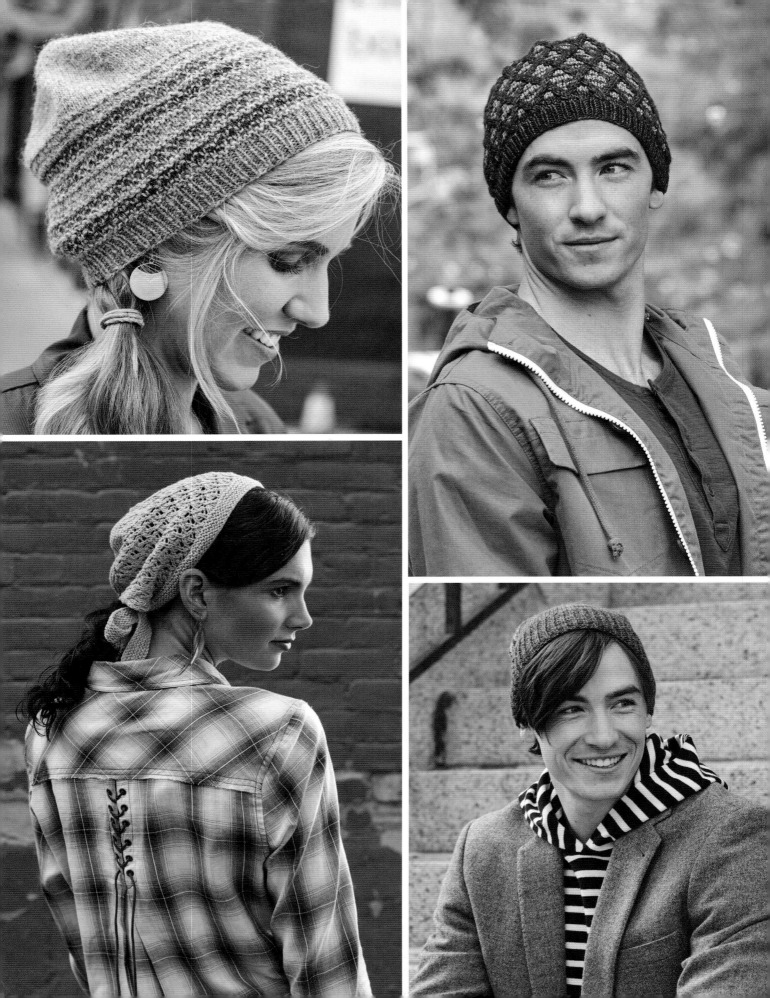

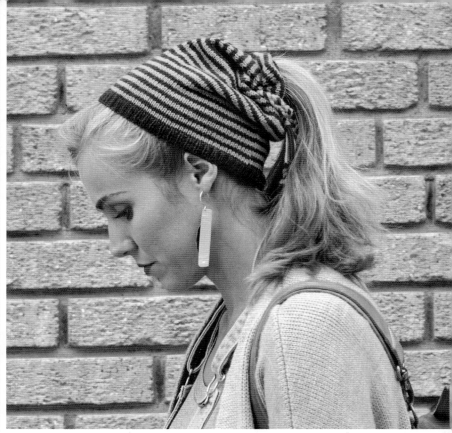
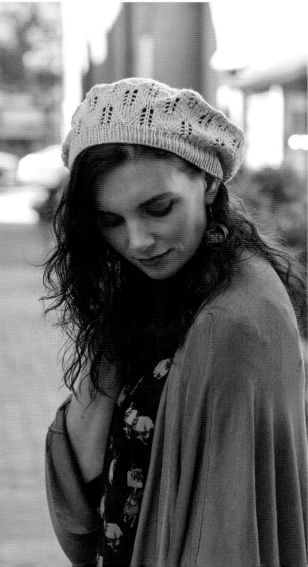

the HATS

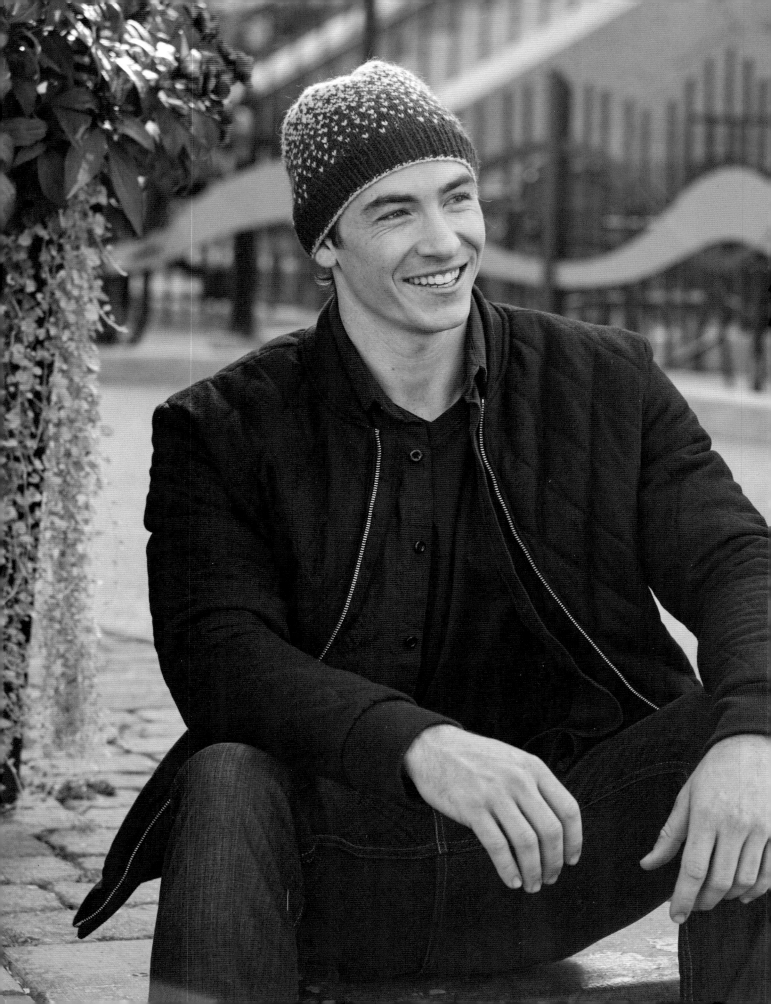

SQUALL COLORWORK BEANIE

Designed by *Annie Rowden*

This simple unisex beanie features an unusual stranded-colorwork pattern. A dark green band merges into the body of the hat, gradually turning gray as the green stitches become more spaced out. The flurry of shifting colors is a joy to create. You can easily change the colors to make any combination you like!

FINISHED SIZE

About 16¼ (18, 19¾)" (41.5 [45.5, 50] cm) circumference at brim and 8¼ (8½, 8¾)" (21 [21.5, 22] cm) tall.

To fit 16½–18 (18¼–20, 20–22)" (42–45.5 [46.5–51, 51–56] cm) head circumference.

Hat shown in 18" (45.5 cm) size.

YARN

Worsted weight (#4 Medium).

Shown here: Quince & Co. Owl (50% wool, 50% alpaca; 120 yd [110 m]/50 g); #321 bog (green; MC) and #303 elf (gray; CC), 1 skein each.

NEEDLES

Brim
Size U.S. 4 (3.5 mm): 16" (40.5 cm) circular (cir).

Body
Size U.S. 6 (4 mm): 16" (40.5 cm) cir and set of 4 or 5 double-pointed (dpn).

Adjust needle sizes if necessary to obtain the correct gauge.

NOTIONS

Marker (m); tapestry needle.

GAUGE

24 sts and 26½ rnds = 4" (10 cm) in Colorwork patt from chart on larger needles.

STITCH GUIDE

K1, P1 Rib in rounds:
(even number of sts)

All rnds: *K1, p1; rep from * to end.

BRIM

With smaller cir needle and CC, use the long-tail method (see Glossary) to CO 90 (100, 110) sts. Cut yarn, leaving an 8" (20.5 cm) tail to weave in later.

With MC, place marker (pm) for beg of rnd and join for working in rnds, being careful not to twist sts. Work in K1, P1 Rib (see Stitch Guide) for 1½" (3.8 cm).

BODY

Change to larger cir needle.

Next rnd: (inc) *K8 (9, 10), k1f&b; rep from * to end—100 (110, 120) sts.

With MC and CC, work Rnds 1–30 of Colorwork chart once.

Next rnd: Knit with CC.

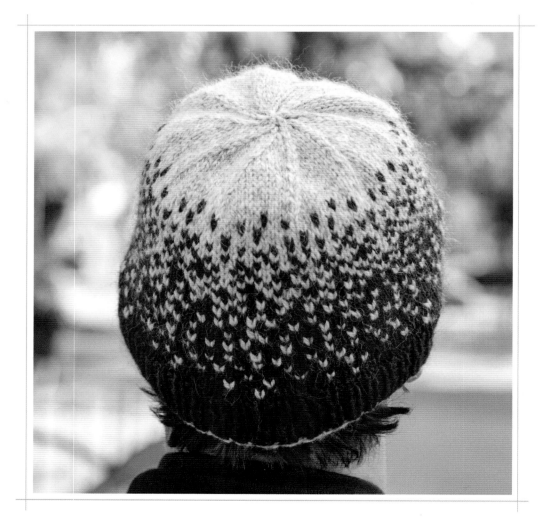

CROWN

The rest of the hat is knit using CC only. Change to dpn when there are too few sts to work comfortably on cir needle.

Set-up Section

Size 16¼":

Skip to All Sizes.

Size 18" only:

Next rnd: *K9, k2tog; rep from * to end—100 sts.
Next rnd: Knit.

Size 19¾" only:

Next rnd: *K10, k2tog; rep from * to end—110 sts.
Next rnd: Knit.
Next rnd: *K9, k2tog; rep from * to end—100 sts.
Next rnd: Knit.

All Sizes

Rnd 1: *K8, k2tog; rep from * to end—90 sts.
Rnds 2, 4, and 6: Knit.
Rnd 3: *K7, k2tog; rep from * to end—80 sts.
Rnd 5: *K6, k2tog; rep from * to end—70 sts.
Rnd 7: *K5, k2tog; rep from * to end—60 sts.
Rnd 8: *K4, k2tog; rep from * to end—50 sts.
Rnd 9: *K3, k2tog; rep from * to end—40 sts.
Rnd 10: *K2, k2tog; rep from * to end—30 sts.
Rnd 11: *K1, k2tog; rep from * to end—20 sts.
Rnd 12: *K2tog; rep from * to end—10 sts.
Rnd 13: Rep Rnd 12—5 sts.

FINISHING

Cut yarn. Thread tail on a tapestry needle, draw through rem sts 2 times, pull tight to close hole, and fasten off on WS.
Weave in loose ends and gently wet-block (see Glossary).

Colorwork

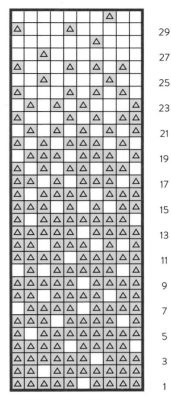

10-st repeat

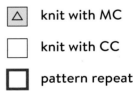

knit with MC

knit with CC

pattern repeat

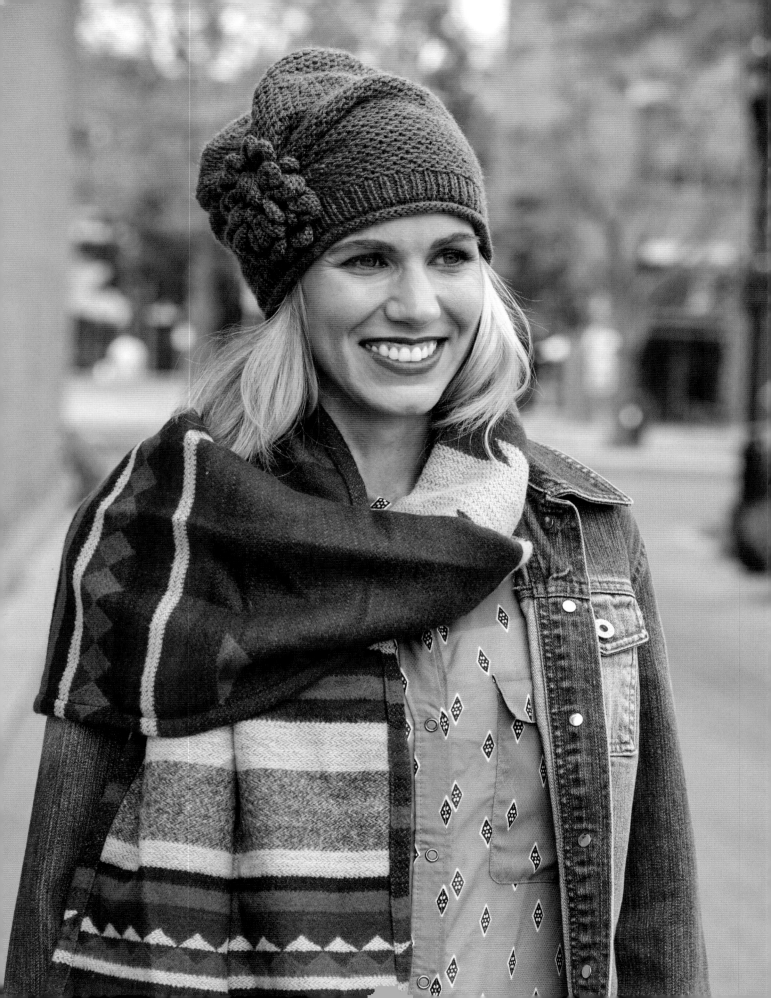

FLORA EMBELLISHED CLOCHE

Designed by *Faina Goberstein*

The knitted bloom on this lovely topper will brighten even the darkest winter day. The flower embellishment is worked separately and sewn in place after the cloche is gathered on the side. A simple slip-stitch pattern adds pretty texture to the crown.

FINISHED SIZE

About 16¾ (18½, 19½, 21¼)" (42.5 [47, 49.5, 54] cm) circumference at brim and 10½ (10½, 11, 11)" (26.5 [26.5, 28, 28] cm) tall.

To fit 17–18 (19–20, 20–21, 22–23)" (43–45.5 [48.5–51, 51–53.5, 56–58.5] cm) head circumference.

Hat shown in 18½" (47 cm) size.

YARN

DK weight (#3 Light).

Shown here: Berroco Vintage DK (52% acrylic, 40% wool, 8% nylon; 288 yd [263 m]/100 g): #2176 pumpkin, 1 (2, 2, 2) skeins.

NEEDLES

Brim
Size U.S. 2 (2.75 mm): 16" (40.5 cm) circular (cir).

Body
Size U.S. 4 (3.5 mm): 16" (40.5 cm) cir and set of 5 double-pointed (dpn).

Adjust needle sizes if necessary to obtain the correct gauge.

NOTIONS

Markers (m); tapestry needle.

GAUGE

24 sts and 50 rnds = 4" (10 cm) in Stamen patt on larger needles.

NOTES

Stitch pattern is written for working in the round. For best results, make a gauge swatch in the round.

All slipped sts in this pattern are slipped purlwise with the yarn in front of the work.

STITCH GUIDE

Sl 1 wyf: Slip 1 st purlwise with yarn in front.

K1, P1 Rib in rounds:
(even number of sts)

All rnds: *K1, p1; rep from * to end.

Stamen Pattern:
(even number of sts)

Rnds 1 and 3: Knit.

Rnd 2: *P1, sl 1 wyf; rep from * to end.

Rnd 4: *Sl 1 wyf, p1; rep from * to end.

Rep Rnds 1–4 for patt.

BRIM

With smaller cir needle, CO 108 (120, 126, 138) sts. Place marker (pm) for beg of rnd and join for working in rnds, being careful not to twist sts.
Knit for 7 rnds, then work 8 rnds in K1, P1 Rib (see Stitch Guide).

BODY

With larger cir needle, work even in Stamen patt from Stitch Guide or chart until hat meas about 7 (7, 7½, 7½)" (18 [18, 19, 19] cm) from beg of rib, ending with Rnd 2 or Rnd 4 of Stamen patt.
Next rnd: *K18 (20, 21, 23), pm; rep from * to end.
Work one more rnd in Stamen patt.

CROWN

Work crown decreases as follows, changing to dpn when there are too few sts to work comfortably on cir needle.

Next rnd: (dec) *K2, k2tog, knit to last 2 sts before m, k2tog, slip marker (sl m); rep from * to end—12 sts dec'd; 96 (108, 114, 126) sts.
Work in est patt for 9 rnds.
Work dec rnd once—12 sts dec'd; 84 (96, 102, 114) sts.
Work in est patt for 7 rnds.
Work dec rnd once—12 sts dec'd; 72 (84, 90, 102) sts.
Work in est patt for 5 rnds.
Work dec rnd once—12 sts dec'd; 60 (72, 78, 90) sts.
Work in est patt for 3 rnds.
Work dec rnd once—12 sts dec'd; 48 (60, 66, 78) sts.
Knit 2 rnds, purl 1 rnd.
Work dec rnd once—12 sts dec'd; 36 (48, 54, 66) sts.
Knit 1 rnd, purl 1 rnd.
Next rnd: *K2tog; rep from * to end—18 (24, 27, 33) sts.
Purl one rnd.
Next rnd: *P2tog; rep from * to last 0 (0, 1, 1) st(s), p0 (0, 1, 1)—9 (12, 14, 17) sts.
Purl 1 rnd.

FINISHING

Cut yarn. Thread tail on a tapestry needle, draw through rem sts, pull tight to close hole, and fasten off on WS. Weave in loose ends.

Flower

CO 342 sts.
Next row: (WS) Purl.
Next row: (RS) Knit.
Next row: (WS) Purl.
Next row: *K1, BO 10 sts; rep from * to end—32 sts.
Cut yarn, leaving an 18" (45.5 cm) tail. Thread tail through rem sts and pull tight, arranging flower in layers like a rose.

Gathering Side of Hat

*Thread tapestry needle with 20" (51 cm) of yarn. Using running stitch (see Glossary), make long basting stitches starting 1" (2.5 cm) above ribbing for about 6" (15 cm) toward the crown. Make a second line of basting stitches about ½" (1.3 cm) to the left of the first line of basting stitches from crown to brim. Pull both ends of basting yarn to gather hat fabric and fasten off on WS. With tail of yarn from flower, attach flower to top of gathered fabric area by sewing through hat fabric and bottom of flower several times. Weave in loose ends.

knit

· purl

⩗ sl 1 wyf

pattern repeat

Stamen

3

1

2-st repeat

DOLCE CABLES and LACE BEANIE

Designed by *Tanis Gray*

This sweet confection makes a fun fashion statement. Knit in a vibrant candy-pink superwash yarn, it features a cabled brim with a scalloped edge and a pretty cabled and lace body. Topping it all off is a jaunty pom-pom.

FINISHED SIZE

About 18" (45.5 cm) circumference at brim and 8" (20.5 cm) tall.

To fit 19½–22" (49.5–56 cm) head circumference.

YARN

Sportweight (#2 Fine).

Shown here: Dragonfly Fibers Damsel (100% superwash merino wool; 335 yd [306 m]/113 g): hot pants, 1 skein.

NEEDLES

Brim
Size U.S. 4 (3.5 mm): 16" (40.5 cm) circular (cir).

Body
Size U.S. 5 (3.75 mm): 16" (40.5 cm) cir and set of 4 or 5 double-pointed (dpn).

Adjust needle sizes if necessary to obtain the correct gauge.

NOTIONS

Marker (m); 2 cable needles (cn); tapestry needle; pom-pom maker (optional).

GAUGES

28 sts and 45½ rnds = 4" (10 cm) in Brim patt on smaller needles after blocking.

26 sts and 34 rnds = 4" (10 cm) in Body patt on larger needles after blocking.

STITCH GUIDE

K1tbl: Knit 1 st through back loop.

Sk2p: Slip 1 st knitwise, k2tog, pass slipped st over decreased st—2 sts dec'd.

7-st cable: Sl 3 sts onto first cable needle (cn) and hold in front, sl 3 sts onto second cn and hold in back, k1tbl, [p1, k1tbl, p1] from 2nd cn, [k1tbl, p1, k1tbl] from first cn.

Brim Pattern: (multiple of 14 sts)

Rnd 1 and all odd-numbered rnds: *K2, [p1, k1tbl] 4 times, p1, k3; rep from * to end.

Rnds 2, 6, 8, and 10: *P1, k1, [p1, k1tbl] 4 times, [p1, k1] 2 times; rep from * to end.

Rnd 4: *P1, k1, p1, 7-st cable, [p1, k1] 2 times; rep from * to end.

Rep Rnds 1–10 for patt.

Body Pattern: (multiple of 14 sts)

Rnds 1 and 2: *K2, p9, k3; rep from * to end.

Rnd 3: *Yo, k1, ssk, p7, k2tog, k1, yo, k1; rep from * to end.

Rnd 4: *K3, p7, k4; rep from * to end.

Rnd 5: *K1, yo, k1, ssk, p5, k2tog, k1, yo, k2; rep from * to end.

Rnd 6: *K4, p5, k5; rep from * to end.

Rnd 7: *K2, yo, k1, ssk, p3, k2tog, k1, yo, k3; rep from * to end.

Rnd 8: *K5, p3, k6; rep from * to end.

Rnd 9: *K3, yo, k1, ssk, p1, k2tog, k1, yo, k4; rep from * to end.

Rnd 10: Knit.

Rep Rnds 1–10 for patt.

BRIM

With smaller cir needle, CO 126 sts. Place marker (pm) for beg of rnd and join for working in rnds, being careful not to twist sts.
Next rnd: Knit.
Next rnd: Purl.
Work Rnds 1–10 of Brim patt from Stitch Guide or chart 2 times, then work Rnds 1–7 once more.

BODY

Change to larger cir needle.
Work Rnds 1–10 of Body patt from Stitch Guide or chart 4 times.

CROWN

Work crown decreases as follows, changing to dpn when there are too few sts to work comfortably on cir needle.
Rnd 1: *Ssk, [p2tog] 2 times, p1, [p2tog] 2 times, k2tog, k1; rep from * to end—72 sts.
Rnd 2: *K1, p5, k2; rep from * to end.
Rnd 3: Remove marker, k1, pm (this marks the new beg of rnd), *p2tog, p1, p2tog, sk2p (see Stitch Guide); rep from * to end—36 sts.
Rnd 4: *P3, k1; rep from * to end.
Rnd 5: *P3tog, k1; rep from * to end—18 sts.
Rnd 6: *K2tog; rep from * to end—9 sts.

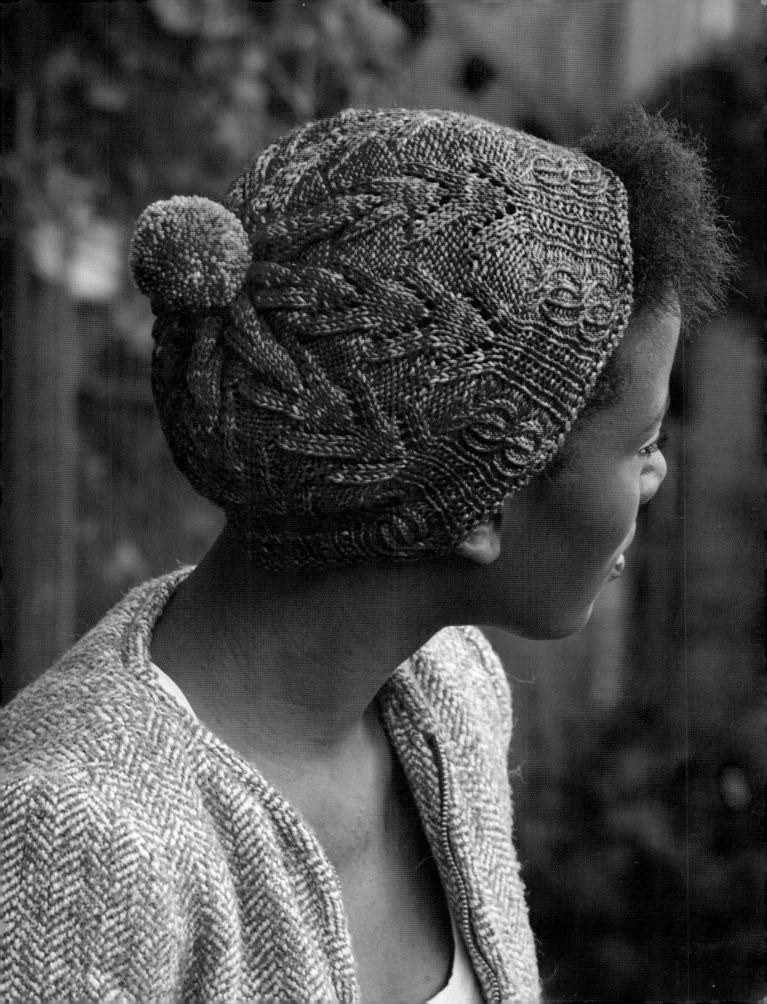

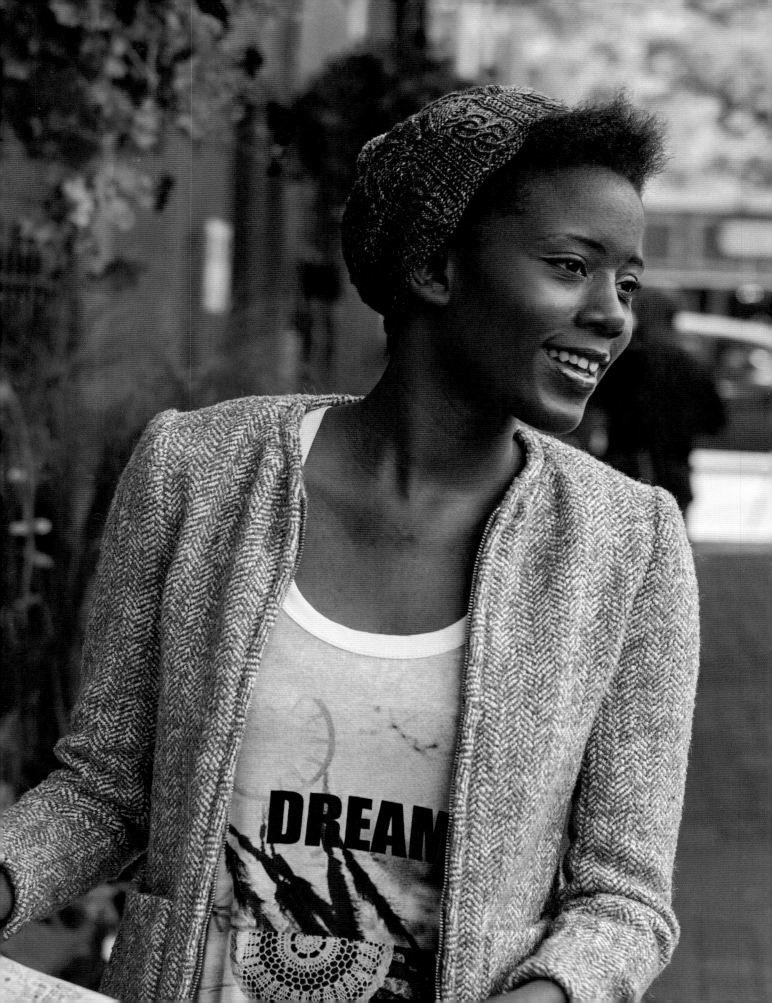

FINISHING

Cut yarn, leaving a 12" (30.5 cm) tail. Thread tail on a tapestry needle, draw through rem sts, pull tight to close hole, and fasten off on WS.
Weave in loose ends. Block.
Make 2" (5 cm) pom-pom (see Glossary) and attach to center top.

Brim

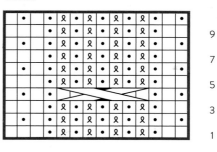

14-st repeat

Body

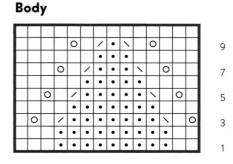

14-st repeat

A Designer's Yarn

My husband and I went on vacation in the fall of 2010. We drove up and down the California coast on Route 1 in a tiny rental car. If you've never experienced driving on that road, it's a dangerous, narrow, windy, twisty, and turny drive, certainly not for the faint of heart! I had brought some knitting with me (of course!) and to keep my mind off the scary drive, I worked on my hat for Interweave the entire way while my husband did the tough drive. That hat ended up being on the cover of Weekend Hats *and I think of that drive every time I see that book!*

—Tanis

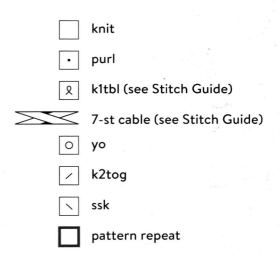

	knit
•	purl
୧	k1tbl (see Stitch Guide)
⤬	7-st cable (see Stitch Guide)
○	yo
╱	k2tog
╲	ssk
▢	pattern repeat

STERLING LACE TAM

Designed by *Heather Zoppetti*

Silvery gray wool-and-silk-blend yarn gives this elegant beret an even more luxe look. The beautiful leaf lace pattern creates a stunning flower focal point on the crown. Lace lovers will swoon!

FINISHED SIZE

About 18" (45.5 cm) circumference at brim and 8½" (21.5 cm) tall; 9¼" (23.5 cm) diameter as a tam.

To fit 22–24" (56–61 cm) head circumference.

YARN

Sportweight (#2 Fine).

Shown here: Stitch Sprouts Yellowstone (80% wool, 20% silk; 285 yd [261 m]/100 g): #SSY001 Old Faithful, 1 skein.

NEEDLES

Size U.S. 6 (4 mm): 16" (40.5 cm) circular (cir) and set of 4 or 5 double-pointed (dpn).

Adjust needle size if necessary to obtain the correct gauge.

NOTIONS

Marker (m); tapestry needle.

GAUGES

26½ sts and 40 rnds = 4" (10 cm) in K1, P1 Rib.

36 sts and 24 rnds = 5⅜" (13.7 cm) wide and 3⅛" (7.9 cm) tall in Main Lace patt.

STITCH GUIDE

Sk2p: Slip 1 knitwise, k2tog, pass slipped st over decreased st—2 sts dec'd.

KOK: K1, yo, k1 in the same st—2 sts inc'd.

K1, P1 Rib in rounds: (even number of sts)

All rnds: *K1, p1; rep from * to end of rnd.

Crown Pattern: (1 st inc'd to 24 sts)

Rnd 1: *K1; rep from * to end.

Rnd 2: *Yo, k1; rep from * to end.

Rnds 3 and 5: Knit.

Rnd 4: *Yo, k1; rep from * to end.

Rnd 6: *[Yo, k1] 2 times, yo, k2tog; rep from * to end.

Rnd 7: *K4, k2tog; rep from * to end.

Rnd 8: *[Yo, k1] 3 times, k2tog; rep from * to end.

Rnd 9: *K5, k2tog; rep from * to end.

Rnd 10: *[Yo, k1] 3 times, k1, k2tog; rep from * to end.

Rnd 11: *K6, k2tog; rep from * to end.

Rnd 12: *Yo, KOK, k2, yo, k2, k2tog; rep from * to end.

Rnd 13: *K8, k2tog; rep from * to end.

Rnd 14: *Yo, k2, KOK, k2, yo, k2, k2tog; rep from * to end.

Rnd 15: *Yo, k1, yo, ssk, k3, k2tog, yo, k2, k2tog; rep from * to end.

Rnd 16: *Yo, k3, yo, k7, k2tog; rep from * to end.

Rnd 17: *Yo, k2tog, yo, k1, [yo, ssk] 2 times, k1, k2tog, yo, k1, k2tog; rep from * to end.

Rnd 18: *K11, k2tog; rep from * to end.

Rnd 19: *Yo, k2tog, k1, [yo, k1] 2 times, ssk, yo, sk2p, yo, k2tog; rep from * to end.

Rnd 20: *K10, k2tog; rep from * to end.

Rnd 21: *Yo, k2tog, k2, [yo, k1] 2 times, k1, ssk, yo, k2tog; rep from * to end.

Rnds 22, 24, 26, 28, 30, 32, 34, and 36: Knit.

Rnd 23: *Yo, k1, yo, ssk, k5, k2tog, [yo, k1] 2 times; rep from * to end.

Rnd 25: *[K1, yo] 2 times, k1, ssk, k3, k2tog, [k1, yo] 2 times, k2; rep from * to end.

Rnd 27: *K2, [yo, k1] 2 times, k1, ssk, k1, k2tog, k2, [yo, k1] 2 times, k2; rep from * to end.

Rnd 29: *Yo, k6, k2tog, yo, k1, yo, ssk, k6, yo, k1; rep from * to end.

Rnd 31: *Yo, k6, k2tog, [k1, yo] 2 times, k1, ssk, k6, yo, k1; rep from * to end.

Rnd 33: *Yo, k6, k2tog, k2, yo, k1, yo, k2, ssk, k6, k1; rep from * to end.

Rnd 35: *Yo, k3, ssk, k1, k2tog, k3, yo, k1; rep from * to end.

Main Lace Pattern: (multiple of 12 sts)

Rnd 1: *K3, k2tog, yo, k1, yo, ssk, k4; rep from * to end.

Rnd 2 and all even-numbered rnds: Knit.

Rnd 3: *K2, k2tog, [k1, yo] 2 times, k1, ssk, k3; rep from * to end.

Rnd 5: *K1, k2tog, k2, yo, k1, yo, k2, ssk, k2; rep from * to end.

Rnd 7: *K2tog, k3, yo, k1, yo, k3, ssk, k1; rep from * to end.

Rnd 9: *Yo, ssk, k7, k2tog, yo, k1; rep from * to end.

Rnd 11: *Yo, k1, ssk, k5, k2tog, k1, yo, k1; rep from * to end.

Rnd 13: *Yo, k2, ssk, k3, k2tog, k2, yo, k1; rep from * to end.

Rnd 15: *Yo, k3, ssk, k1, k2tog, k3, yo, k1; rep from * to end.

Rep Rnds 1–16 for patt.

CROWN

Using Emily Ocker's Circular Beginning (see Glossary) and dpn, CO 6 sts. Place marker (pm) for beg of rnd. Changing to cir needle when there are too many sts to fit on the dpn, work Rnds 1–36 of Crown patt from Stitch Guide or chart—144 sts.

BODY

Work Rnds 1–16 of Main Lace patt from Stitch Guide or chart once, then work Rnds 1–7 once more.

Next rnd: Knit to last 2 sts, temporarily slip the last 2 sts of the rnd to the right needle, remove marker, return the slipped sts to the left needle, and replace the marker on the right needle for new beg of rnd.

Next rnd: (dec) Sk2p (see Stitch Guide), k9; rep from * to end of rnd—120 sts.

BRIM

Work in K1, P1 Rib (see Stitch Guide) until brim meas 1" (2.5 cm) slightly stretched. BO all sts in patt.

FINISHING

Block over a plate. Weave in loose ends.

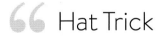 Hat Trick

When blocking a hat over a plate, thread yarn between the brim and body to cinch tight. This keeps the brim from stretching out.

—Heather

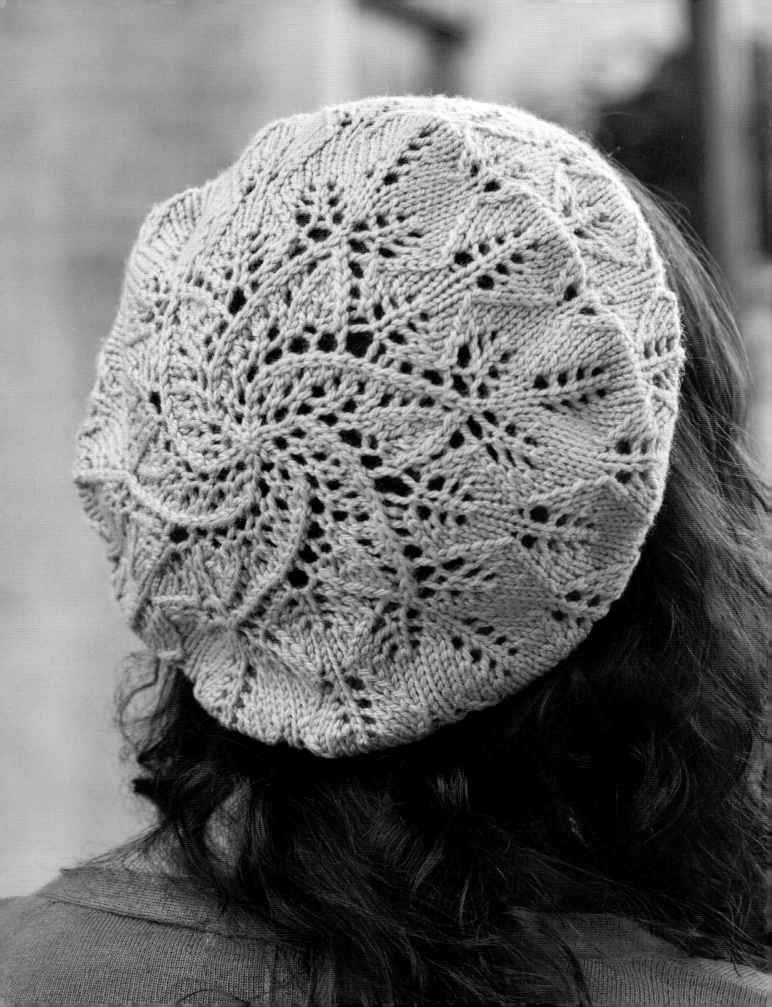

- ☐ knit
- ☐• purl
- ☐○ yo
- ☐╱ k2tog
- ☐╲ ssk
- ☐⅄ sk2p (see Stitch Guide)
- KOK (see Stitch Guide)
- ☐ no stitch
- ☐ pattern repeat

Main Lace

12-st repeat

Crown

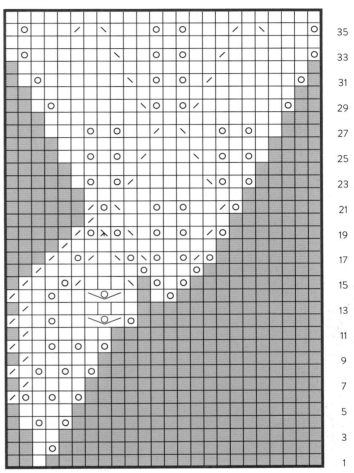

1 st inc'd to 24 sts

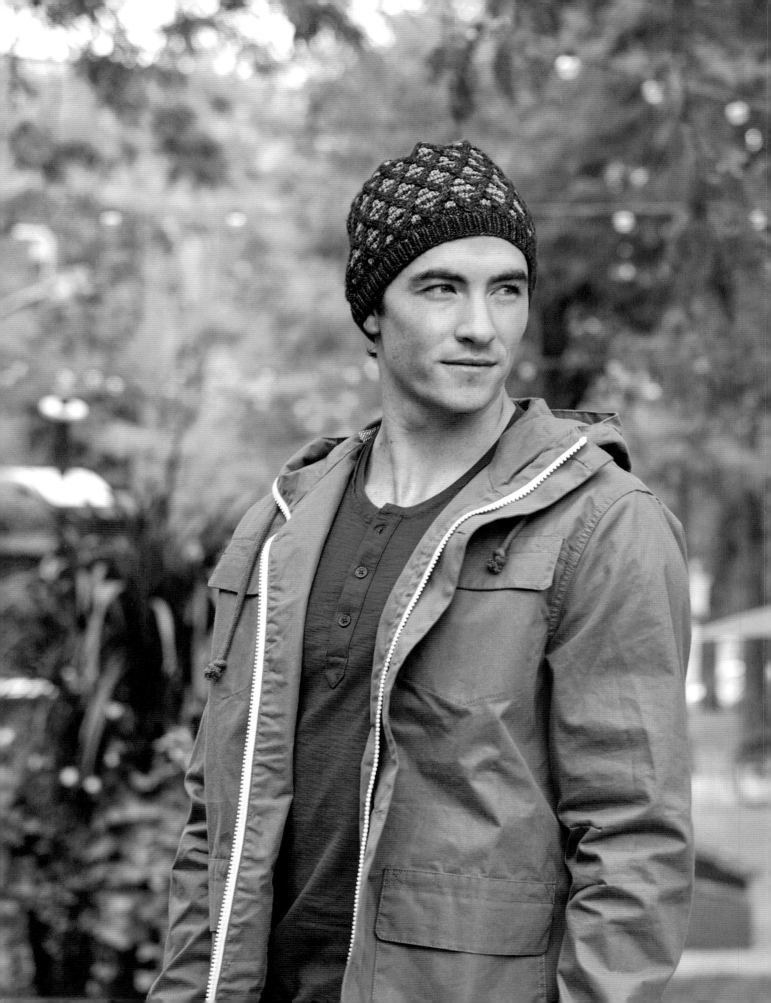

CRISSCROSS SLIP-STITCH BEANIE

Designed by *Faina Goberstein*

Worked in a slip-stitch lattice pattern, this versatile hat features two contrasting colors that create an interesting graphic effect. The crown decreases are done in a way that preserves the integrity of the pattern while forming a stellar interwoven pattern on their own.

FINISHED SIZE

16¾ (18, 19¼)" (42.5 [45.5, 49] cm) circumference at brim, unstretched, and 8¾" (22 cm) tall.

To fit 16¾–18 (18–20¼, 20¼–22½)" (42.5–45.5 [45.5–51.5, 51.5–57] cm) head circumference.

Hat shown in 18" (45.5 cm) size.

YARN

DK weight (#3 Light).

Shown here: Hazel Knits Lively DK (90% superwash merino wool, 10% nylon; 275 yd [251 m]/130 g): Emerald City (MC; blue) and hoppy blonde (CC; yellow), 1 skein each.

NEEDLES

Brim
Size U.S. 3 (3.25 mm): 16" (40.5 cm) circular (cir).

Body
Size U.S. 5 (3.75 mm): 16" (40.5 cm) cir and set of 5 double-pointed (dpn).

Adjust needle sizes if necessary to obtain the correct gauge.

NOTIONS

Marker (m); cable needle; tapestry needle.

GAUGES

26½ sts and 35½ rnds = 4" (10 cm) in K1, P1 Rib on smaller needles.

28½ sts and 46½ rnds = 4" (10 cm) in Lattice patt from chart on larger needles.

NOTES

Stitch pattern is written for working in the round. For best results, make a gauge swatch in the round.

All slipped sts in this pattern are slipped purlwise with yarn in back of work.

STITCH GUIDE

Sl 1: Slip purlwise with yarn in back.

2/1 LC: Sl 2 sts onto cn and hold in front, k1, k2 from cn.

2/1 RC: Sl 1 st onto cn and hold in back, k2, k1 from cn.

2/2 LC: Sl 2 sts onto cn and hold in front, k2, k2 from cn.

2/2 RC: Sl 2 sts onto cn and hold in back, k2, k2 from cn.

K1, P1 Rib in rounds: (even number of sts)

All rnds: *K1, p1; rep from * to end.

Lattice Pattern: (multiple of 8 sts)

Note: The beginning of the round shifts 2 stitches to the left in Rnd 2.

Rnd 1: With MC, slip marker (sl m), *2/2 LC, k4; rep from * to end.

Rnd 2: Remove marker, k2 with MC, place marker (pm) for new beg of rnd, *k8; rep from * to end.

Rnds 3, 4, 23, and 24: *Sl 2, k4 with CC, sl 2; rep from * to end.

Rnd 5: With MC, *2/1 LC, k2, 2/1 RC; rep from * to end.

Rnds 6, 10, 14, 18, and 22: With MC, knit.

Rnds 7, 8, 19, and 20: With CC, *k1, sl 2, k2, sl 2, k1; rep from * to end.

Rnd 9: With MC, *k1, 2/1 LC, 2/1 RC, k1; rep from * to end.

Rnds 11, 12, 15, and 16: With CC, *k2, sl 4, k2; rep from * to end.

Rnd 13: With MC, *k2, 2/2 RC, k2; rep from * to end.

Rnd 17: With MC, *k1, 2/1 RC, 2/1 LC, k1; rep from * to end.

Rnd 21: With MC, *2/1 RC, k2, 2/1 LC; rep from * to end.

Rep Rnds 1–24 for patt.

BRIM

With MC and smaller cir needle, CO 112 (120, 128) sts. Place marker (pm) for beg of rnd and join for working in rnds, being careful not to twist sts.
Work 8 rnds of K1, P1 Rib (see Stitch Guide).

BODY

Next rnd: (inc) With MC and larger cir needle, *k7 (5, 4), M1 (see Glossary); rep from * to end—128 (144, 160) sts. Work even in Lattice patt from Stitch Guide or chart until hat meas about 6¼" (16 cm) from CO edge, ending after Rnd 13 of Lattice patt.

CROWN

Note: To keep the flow of the patt, the beginning of the round shifts on Rnds 11 and 12.

Work crown decreases as follows, changing to dpn when there are too few sts to work comfortably on cir needle.

Rnd 1: (dec) With MC, k2, *[k2tog] 2 times, k12; rep from * to last 14 sts, [k2tog] 2 times, k10—112 (126, 140) sts.

Rnds 2 and 3: With CC, K8, *sl 4, k10; rep from * to last 6 sts, sl 4, k2.

Rnd 4: With MC, K7, *2/1 RC, 2/1 LC, k8; rep from * to last 7 sts, 2/1 RC, 2/1 LC, k1.

Rnd 5: (dec) With MC, k2tog, k2, k2tog, *k8, k2tog, k2, k2tog; rep from * to last 8 sts, k8—96 (108, 120) sts.

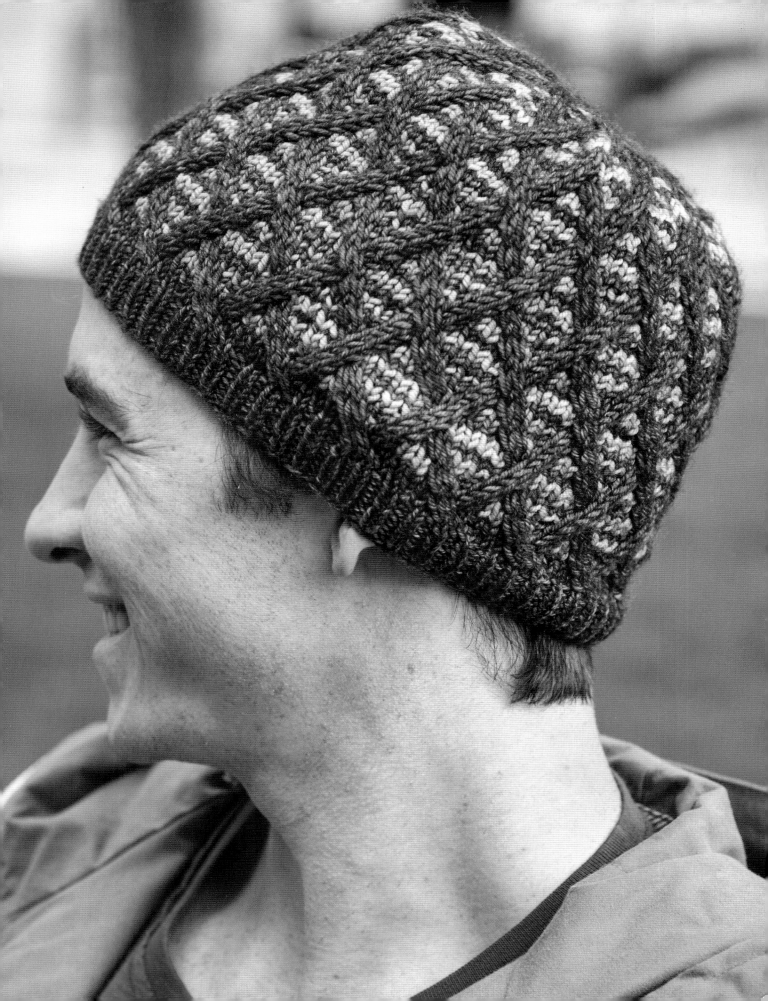

Rnd 6: With CC, k5, *sl 2, k2, sl 2, k6; rep from * to last 7 sts, sl 2, k2, sl 2, k1.

Rnd 7: (dec) With CC, k2tog, k1, k2tog, *sl 2, k2, sl 2, [k1, k2tog] 2 times; rep from * to last 7 sts, sl 2, k2, sl 2, k1—80 (90, 100) sts.

Rnd 8: With MC, *k2, 2/1 RC, k2, 2/1 LC; rep from * to end.

Rnd 9: Knit with MC.

Rnd 10: (dec) With CC, *k2, sl 2, [k2tog] 2 times, sl 2; rep from * to end—64 (72, 80) sts.

Rnd 11: With CC, *k2, sl 2; rep from * to last 4 sts, k2. Temporarily slip the last 2 sts of the rnd to the right needle, remove marker, return the slipped stitches to the left needle; with MC, 2/1 LC and replace the marker on the right needle.

Rnd 12: With MC, *2/1 RC, k2, 2/1 LC; rep from * to last 8 sts, 2/1 RC, k4. Temporarily slip the last st of the rnd to the right needle, remove marker, return the slipped stitch to the left needle, and replace the marker on the right needle. Next st will be worked as first st of Rnd 13.

Rnd 13: (dec) With MC, *sl 2 sts to cn and hold in front, k2tog, k2tog from cn, k4; rep from * to end—48 (54, 60) sts.

Rnd 14: (dec) With CC, *sl 2, [k2tog] 2 times; rep from * to end—32 (36, 40) sts.

Rnd 15: With CC, *sl 2, k2; rep from * to end.

Rnd 16: (dec) With MC, *k2, k2tog; rep from * to end—24 (27, 30) sts.

Rnd 17: Knit with MC.

Rnd 18: (dec) With MC, *k1, k2tog; rep from * to end—16 (18, 20) sts.

FINISHING

Cut yarn. Thread tail on a tapestry needle, draw through rem sts, pull tight to close hole, and fasten off on WS. Weave in loose ends.

Lattice

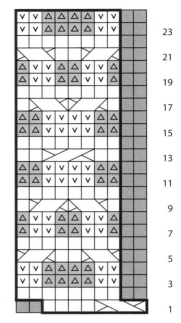

8-st repeat

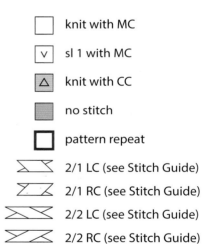

	knit with MC
v	sl 1 with MC
△	knit with CC
	no stitch
	pattern repeat
	2/1 LC (see Stitch Guide)
	2/1 RC (see Stitch Guide)
	2/2 LC (see Stitch Guide)
	2/2 RC (see Stitch Guide)

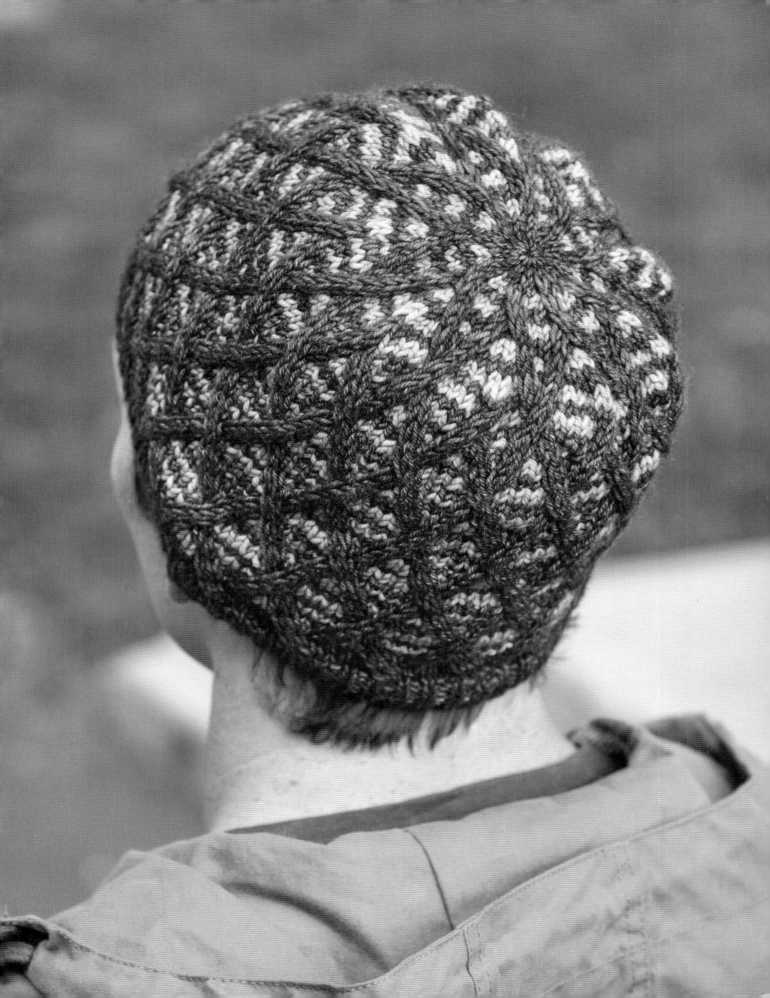

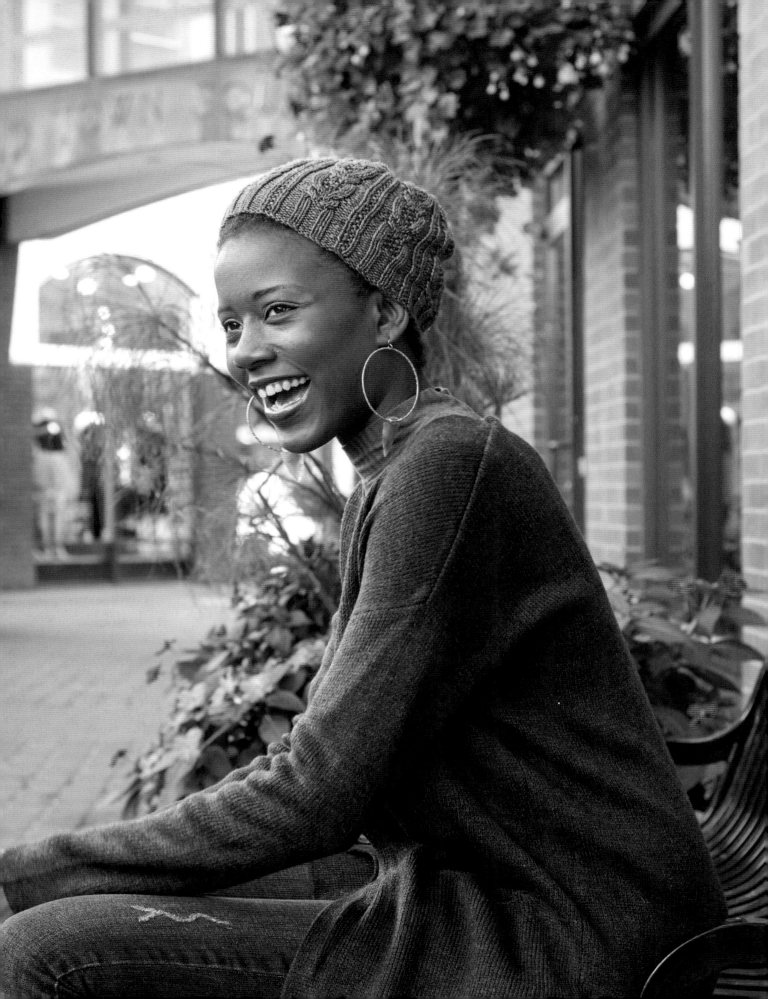

SEAGLASS CABLED HAT

Designed by *Melissa Thomson*

A simple beanie shape is elevated with a rich cable and ribbing pattern. The luxurious cashmere-blend yarn is a pleasure to knit, and the gorgeous marine blue color will flatter any complexion.

FINISHED SIZE

About 14½" (37 cm) circumference at brim, unstretched, and 8¼" (21 cm) tall.

To fit 17–19" (43–48.5 cm) head circumference.

YARN

Worsted weight (#4 Medium).

Shown here: Sweet Fiber Yarns Cashmerino Worsted (80% superwash merino wool, 10% cashmere, 10% nylon; 200 yd [183 m]/115 g): sea glass, 1 skein.

NEEDLES

Brim
Size U.S. 5 (3.75 mm): 16" (40.5 cm) circular (cir).

Body
Size U.S. 7 (4.5 mm): 16" (40.5 cm) cir and set of 4 or 5 double-pointed (dpn).

Adjust needle sizes if necessary to obtain the correct gauge.

NOTIONS

Marker (m); cable needle (cn); tapestry needle.

GAUGE

30 sts and 42 rnds in Body patt = 4½" (11.5 cm) wide and 5¼" (13.5 cm) tall on larger needles, unstretched.

STITCH GUIDE

2/1 LC: Sl 2 sts onto cn and hold in front, k1, k2 from cn.

2/1 RC: Sl 1 st onto cn and hold in back, k2, k1 from cn.

2/2 LC: Sl 2 sts onto cn and hold in front, k2, k2 from cn.

2/2 RC: Sl 2 sts onto cn and hold in back, k2, k2 from cn.

Skp: Slip 1 knitwise, knit 1, pass slipped stitch over—1 st dec'd.

S2kp: Slip 2 sts as if to k2tog, knit 1, pass 2 slipped stitches over—2 sts dec'd.

Body Pattern: (multiple of 30 sts)

Rnd 1: *P2, k8, p2, k1, p1, k1, p2, k3, p1, k1, p1, k2, p2, k1, p1, k1; rep from * to end.

Rnd 2: *P2, 2/2 RC, 2/2 LC, p2, k3, p2, k2, p1, k1, p1, k3, p2, k3; rep from * to end.

Rnd 3: Rep Rnd 1.

Rnd 4: *P2, k8, p2, k3, p2, k2, p1, k1, p1, k3, p2, k3; rep from * to end.

Rnds 5 and 6: Rep Rnds 1 and 2.

Rnd 7: *P2, k2, p1, k1, p1, k3, p2, k1, p1, k1, p2, k3, p1, k1, p1, k2, p2, k1, p1, k1; rep from * to end.

Rnd 8: *P2, k3, p1, k1, p1, k2, p2, k3, p2, k8, p2, k3; rep from * to end.

Rnd 9: *P2, k2, p1, k1, p1, k3, p2, k1, p1, k1, p2, k8, p2, k1, p1, k1; rep from * to end.

Rnd 10: *P2, k3, p1, k1, p1, k2, p2, k3, p2, 2/2 RC, 2/2 LC, p2, k3; rep from * to end.

Rnd 11: Rep Rnd 9.

Rnds 12 and 13: Rep Rnds 8 and 9.

Rnd 14: *P2, k8, p2, k3, p2, 2/2 RC, 2/2 LC, p2, k3; rep from * to end.

Rep Rnds 1–14 for patt.

Crown Pattern: (30 sts dec'd to 12 sts)

Rnd 1: *P2, ssk, k4, k2tog, p2, k3, p2, k1, ssk, k1, p1, k2tog, k1, p2, k3; rep from * to end—26 sts per rep.

Rnd 2: *P2tog, 2/1 RC, 2/1 LC, p2tog, k1, p1, k1, p2tog, k2, p1, k3, p2tog, k1, p1, k1; rep from * to end—22 sts per rep.

Rnd 3: *P1, ssk, k2, k2tog, p1, k3, p1, k1, ssk, k2tog, k1, p1, k3; rep from * to end—18 sts per rep.

Rnd 4: *P1, k4, [p1, k1] 3 times, skp, [k1, p1] 2 times, k1; rep from * to end—17 sts per rep.

Rnd 5: *P1, ssk, k2tog, [p1, k3] 3 times; rep from * to end—15 sts per rep.

Rnd 6: *P1, k2, [p1, k1] 2 times, p1, k3, [p1, k1] 2 times; rep from * to end—15 sts per rep.

Rnd 7: *P1, skp, p1, k3, p1, s2kp, p1, k3; rep from * to end—12 sts per rep.

BRIM

Using smaller cir needle, CO 104 sts. Place marker (pm) for beg of rnd and join for working in rnds, being careful not to twist sts.
Rnd 1: *[P2, k2] 2 times, p2, k3; rep from * to end.
Rnd 2: *[P2, k2] 2 times, p2, k1, p1, k1; rep from * to end.
Rep Rnds 1 and 2 until piece meas 1½" (3.8 cm) from CO edge, ending after Rnd 2.

BODY

Change to larger cir needle.
Set-up rnd: *P2, [k2, M1 (see Glossary)] 2 times, k2, p2, k3; rep from * to end—120 sts.
Work Rnds 1–14 of Body patt from Stitch Guide or chart a total of 3 times. Then work Rnds 1–3 of Body patt once more.

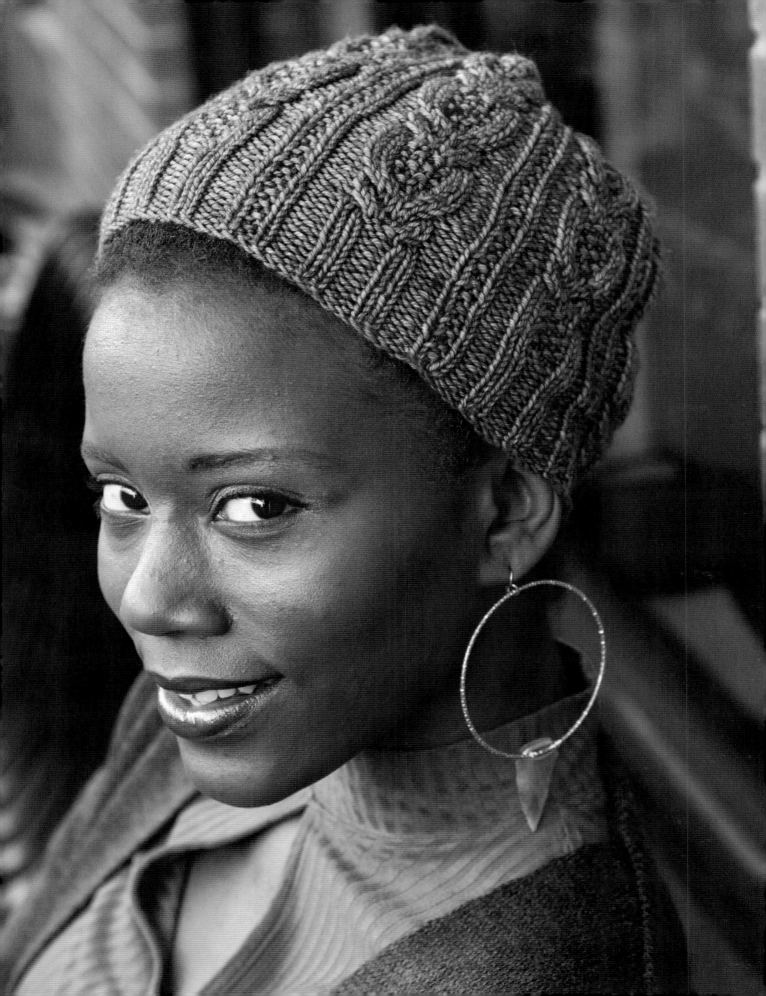

CROWN

Changing to dpn when there are too few sts to work comfortably on cir needle, work Rnds 1–7 of Crown patt from Stitch Guide or chart—48 sts.

Next rnd: Remove marker, p1, pm, *k1, k2tog, p1, ssk; rep from * to end—32 sts.

Next rnd: Remove marker, slip 1 st from right needle to left needle, pm, *s2kp (see Stitch Guide), k1; rep from * to end—16 sts.

FINISHING

Cut yarn, leaving an 8" (20.5 cm) tail. Thread tail on a tapestry needle, draw through rem sts, pull tight to close hole from the wrong side, and fasten off on WS. Weave in loose ends and block as desired.

Hat Trick

Blocking your hat can have a huge impact on the look and feel of the finished project. If it's cabled or lacy, try stretching the crown over a bowl to really open up the pattern and show off your hard work. Just be sure never to stretch the ribbing! I like to pick a bowl that is shallower than the hat, so I can place it upside-down on a glass or other stand and allow the ribbing to hang freely and pull in as it dries.

—Melissa

Body

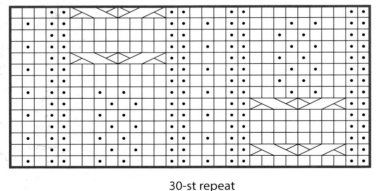

13
11
9
7
5
3
1

30-st repeat

Crown

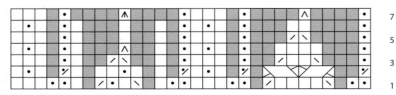

7
5
3
1

30 sts dec'd to 12 sts

	knit
•	purl
/	k2tog
\	ssk
ʌ	s2kp (see Stitch Guide)
⅄	p2tog
∧	skp (see Stitch Guide)
	2/1 LC (see Stitch Guide)
	2/1 RC (see Stitch Guide)
	2/2 LC (see Stitch Guide)
	2/2 RC (see Stitch Guide)
	no stitch
	pattern repeat

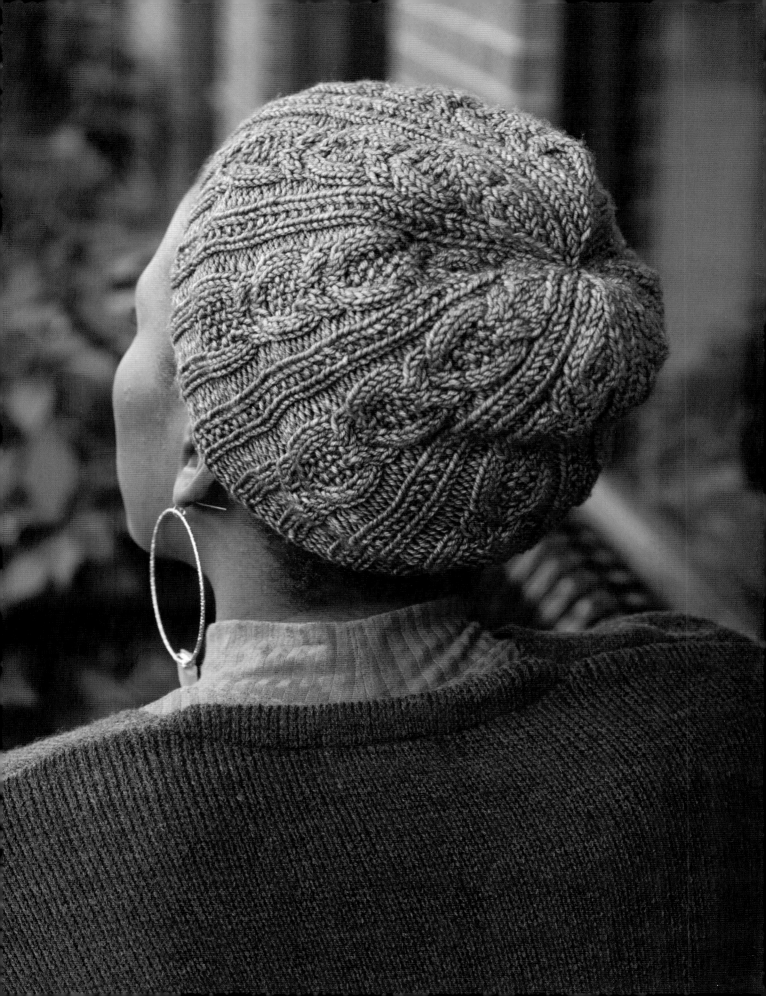

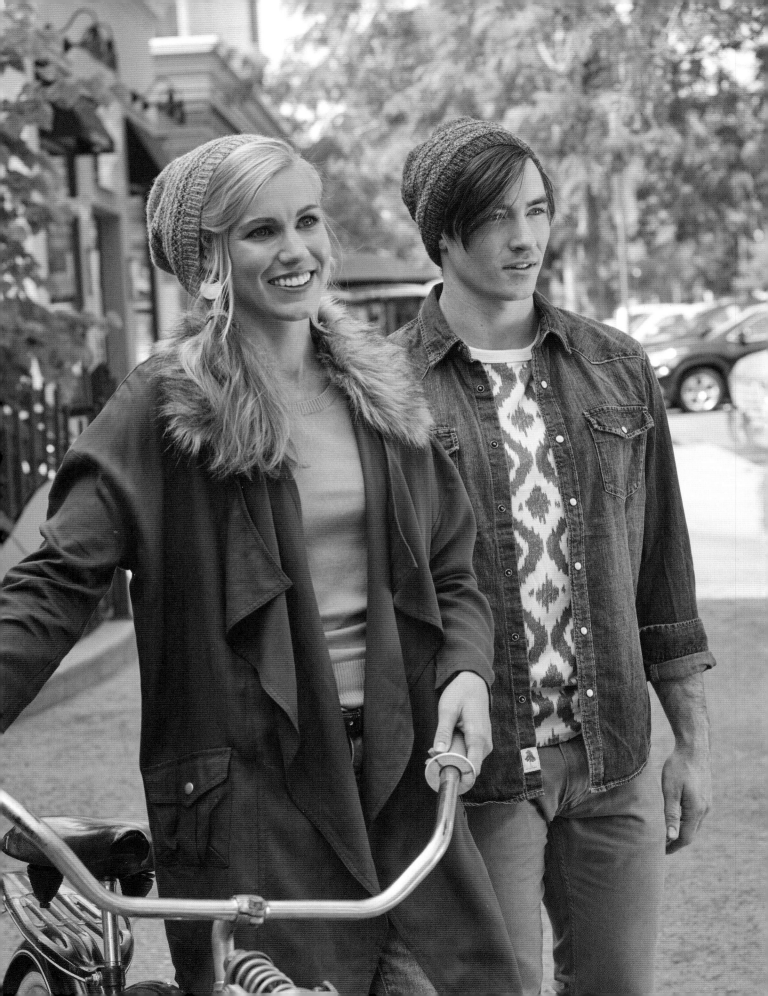

REVOLVE HIS and HERS BEANIES

Designed by *Robin Ulrich*

Subtly colorful stripes—three wide or six skinny, depending on your preference—encircle this pair of beanies. Each stripe is worked in a stranded pattern of heathery yarns, creating a graphic, yet understated, effect.

FINISHED SIZE

About 18" (45.5 cm) circumference at brim, unstretched, and 10" (25.5 cm) tall.

To fit 19–22" (48.5–56 cm) head circumference.

YARN

Fingering weight (#1 Super Fine).

Shown here: Jamieson's Shetland Spindrift (100% Shetland wool; 115 yd [105 m]/25 g):

3-Stripe Version
#123 Oxford (dark gray; MC), 2 balls; #365 chartreuse (yellow-green; CC1), #1010 seabright (light blue; CC2), and #103 sholmit (medium gray; CC3), 1 ball each.

6-Stripe Version
#103 sholmit (medium gray; MC), 2 balls; #123 Oxford (dark gray; CC1), #1020 nighthawk (dark teal; CC2), and #1010 seabright (light blue; CC3), 1 ball each.

NEEDLES

Brim
Size U.S. 1 (2.25 mm): 16" (40.5 cm) circular (cir).

Body
Size U.S. 2 (2.75 mm): 16" (40.5 cm) cir and set of 4 double-pointed (dpn).

Adjust needle sizes if necessary to obtain the correct gauge.

NOTIONS

Markers (m); tapestry needle.

GAUGES

26 sts and 32 rnds = 4" (10 cm) in St st on larger needles.

26 sts and 38 rnds = 4" (10 cm) in Revolve Stripe patt (3-stripe version) on larger needles.

26 sts and 42 rnds = 4" (10 cm) in Revolve Stripe patt (6-stripe version) on larger needles.

STITCH GUIDE

K1, P1 Rib in rounds: (even number of sts)

All rnds: *K1, p1; rep from * to end

Revolve Stripe Pattern: (multiple of 4 sts)

Rnd 1 and all odd-numbered rnds: Knit with MC.

Rnd 2: Purl with MC.

Rnds 4, 8, and 12: *With CC, k1, p1; rep from * to end.

Rnds 6 and 10: *With CC, p1, k1; rep from * to end.

Rep Rnds 1–6 (1–12) for 6-stripe (3-stripe) version.

BODY

Change to larger cir needle.

3-Stripe Version

With MC and CC1, work Rnds 1–12 of Revolve Stripe patt (see Stitch Guide). Fasten off CC1.
With MC and CC2, work Rnds 1–12 of Revolve Stripe patt. Fasten off CC2.
With MC and CC3, work Rnds 1–12 of Revolve Stripe patt. Fasten off CC3.

6-Stripe Version

*With MC and CC1, work Rnds 1–6 of Revolve Stripe patt (see Stitch Guide). Fasten off CC1.
With MC and CC2, work Rnds 1–6 of Revolve Stripe patt. Fasten off CC2.
With MC and CC3, work Rnds 1–6 of Revolve Stripe patt. Fasten off CC3.
Rep from * once more.

BRIM

With smaller cir needle and MC, CO 136 sts. Place marker (pm) for beg of rnd and join for working in rnds, being careful not to twist sts.
With MC, work in K1, P1 Rib (see Stitch Guide) until piece meas 1¼" (3.2 cm).

❝ Hat Trick

When joining stitches to work a hat in the round, it helps to first lay the work on a flat surface in front of you to ensure your stitches are not twisted.

—*Robin* ❞

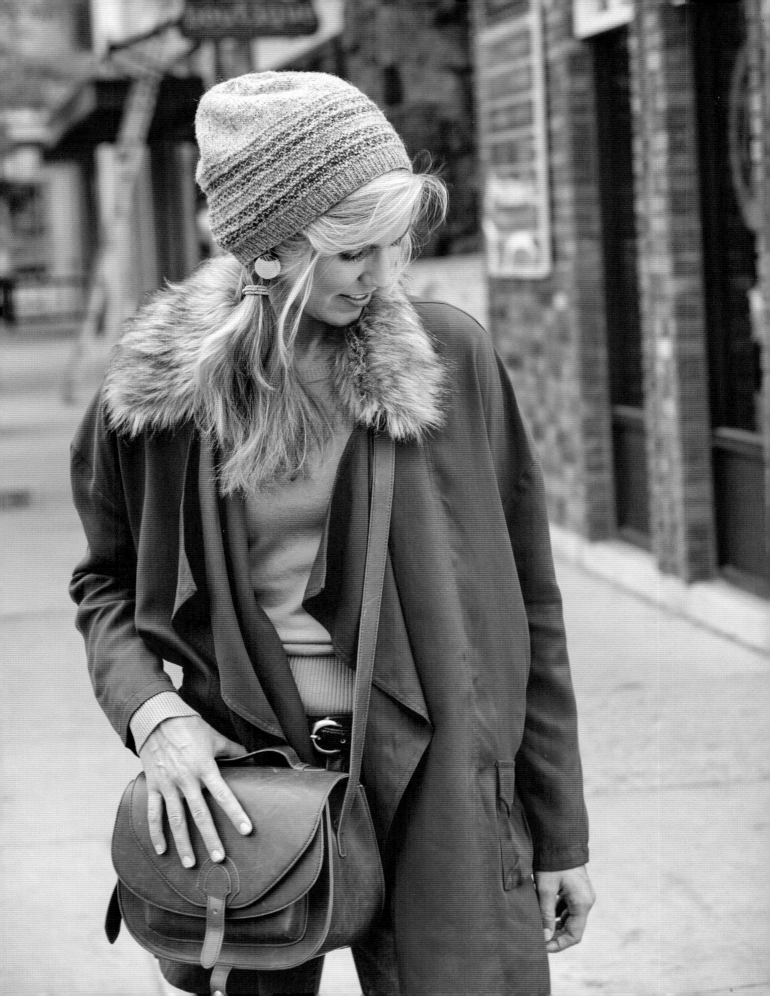

Both Versions

The rest of the hat is knit with MC only.

Next rnd: Knit.

Next rnd: Purl.

Work in St st (knit every rnd) until piece meas 6½" (16.5 cm) from CO edge.

Next rnd: [K17, pm] 7 times, knit to end.

CROWN

Work crown decreases as follows, changing to dpn when there are too few sts to work comfortably on cir needle.

Next rnd: (dec) *Knit to 2 sts before m, k2tog, slip marker (sl m); rep from * to end—8 sts dec'd.

Next rnd: Knit.

Rep the last 2 rnds until 2 sts rem between markers—16 sts.

Next rnd: (dec) *K2tog, remove m; rep from * to end—8 sts.

Cut yarn, leaving an 8" (20.5 cm) tail. Thread tail on a tapestry needle, draw through rem sts, pull tight to close hole, and fasten off on WS.

FINISHING

Weave in loose ends. Soak hat in gentle wool wash. Carefully press out excess moisture and block lightly, leaving ribbing unstretched.

" A Designer's Yarn

The first hat I knit was a simple ribbed beanie I designed as a Christmas gift for my thirteen-year-old nephew. I worried he wouldn't like the hat, but upon receiving it, his face lit up, he promptly put it on and wore it for the entire holiday weekend. His enthusiastic response encouraged me to keep knitting and designing more hats.

—*Robin* "

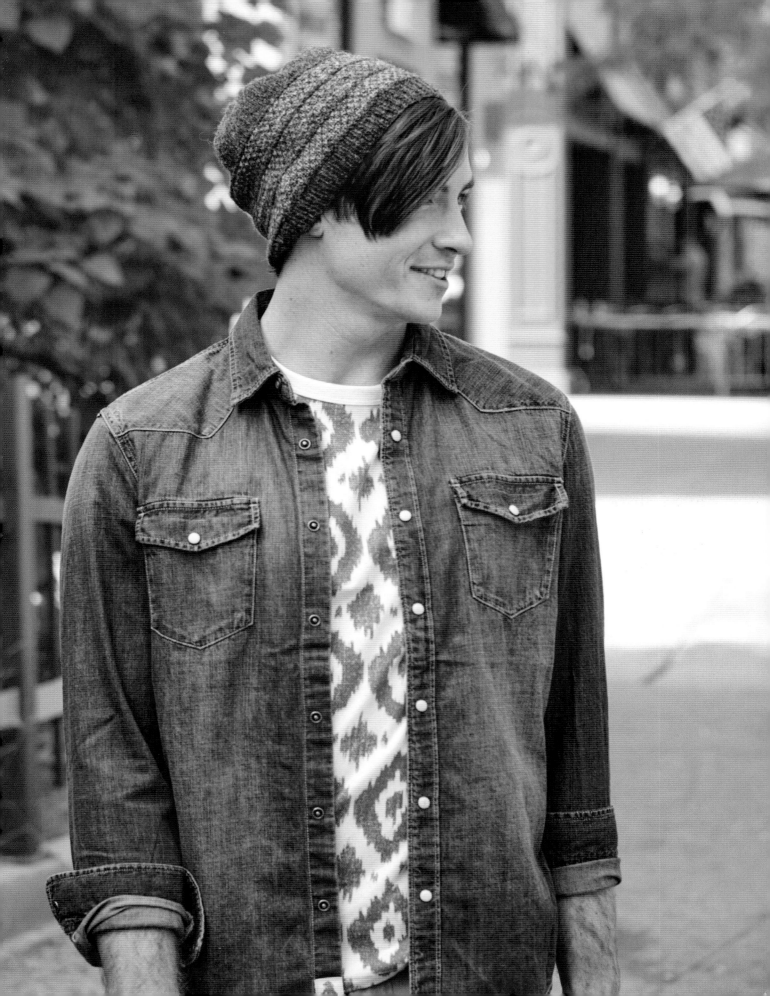

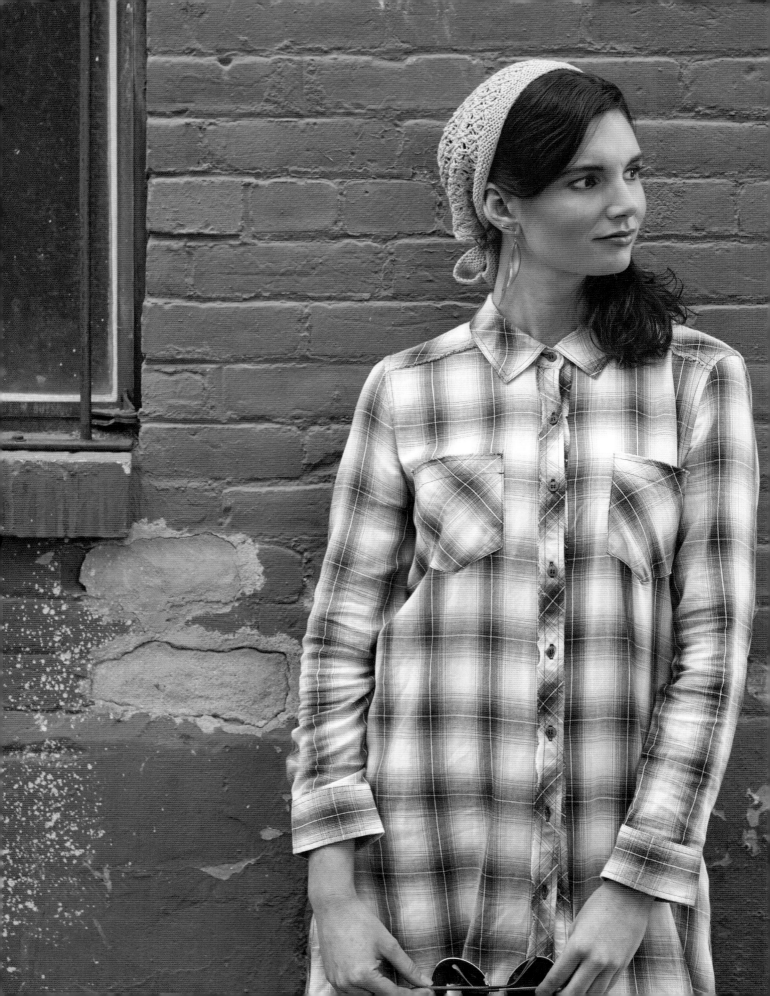

SUNSHINE LACE KERCHIEF

Designed by *Courtney Spainhower*

The onset of warm weather is normally a sign to store our beloved handknit hats until cooler air returns, but this lightweight cap easily transitions to spring and summer. A delicate knit, it's worked seamlessly in a blend of soft linen and silk.

FINISHED SIZE

About 8¼" (21 cm) deep from front to back and 9" (21 cm) tall from neck edge to top of head; each tie is 12½" (31.5 cm) long.

To fit 20–22" (51–56 cm) head circumference.

YARN

Sportweight (#2 Fine).

Shown here: Anzula Vera (65% silk, 35% linen; 365 yd [334 m]/115 g): curry, 1 skein.

NEEDLES

Size U.S. 4 (3.5 mm): 24" (61 cm) circular (cir) and set of 4 or 5 double-pointed (dpn).

Adjust needle size if necessary to obtain the correct gauge.

NOTIONS

Markers (m); tapestry needle.

GAUGES

20½ sts and 44 rows = 4" (10 cm) in garter st.

30 sts and 32 rows = 5¼" (13.5 cm) wide and 3¾" (9.5 cm) tall in English Mesh Lace patt.

STITCH GUIDE

Sk2p: Slip 1 st knitwise, k2tog, pass slipped st over decreased st—2 sts dec'd.

Skp: Slip 1 st knitwise, k1, pass slipped stitch over—1 st dec'd.

English Mesh Lace Pattern: (multiple of 6 sts + 7)

Row 1 and all odd-numbered rows: (WS) Purl.

Row 2: (RS) K1, *yo, ssk, k1, k2tog, yo, k1; rep from * to end.

Row 4: K1, *yo, k1, sk2p, k1, yo, k1; rep from * to end.

Row 6: K1, *k2tog, yo, k1, yo, ssk, k1; rep from * to end.

Row 8: K2tog, *[k1, yo] 2 times, k1, sk2p; rep from * to last 5 sts, [k1, yo] 2 times, k1, ssk.

Rep Rows 1–8 for patt.

Rnd 1: Knit.

Rnds 2 and 4: Purl.

Rnd 3: K6, skp (see Stitch Guide), *k13, skp; rep from * to last 5 sts, k5—96 sts.

Rnd 5: *K10, skp, pm; rep from * to last 12 sts, k10, skp—88 sts.

Rnd 6: Purl.

Rnd 7: *Knit to 2 sts before m, skp; rep from * to end—80 sts.

Rep Rnds 6 and 7 three more times—56 sts.

Next rnd: *Purl to 2 sts before m, p2tog; rep from * to end—48 sts.

Next rnd: *Knit to 2 sts before m, skp; rep from * to end—40 sts.

Rep the last 2 rnds 2 more times—8 sts.

Cut yarn. Thread tail on a tapestry needle, draw through rem sts, pull tight to close hole, and fasten off on WS.

FINISHING

Using tapestry needle, weave in loose ends neatly. Wet-block (see Glossary).

FRONT BANDS AND TIES

With cir needle, CO 231 sts. Do not join for working in the rnd. Work even in garter st (knit every row) until piece meas about 1" (2.5 cm) from CO edge, ending after a RS row.

Next row: (WS) BO 64, p103, BO 64, cut yarn—103 sts.

BODY

Rejoin working yarn with RS facing and work Rows 2–8 of English Mesh Lace patt from Stitch Guide or chart once, then work Rows 1–8 five more times.

CROWN

Change to dpn, distributing sts evenly on needles, place marker (pm) for beg of rnd, and join for working in rnds.

English Mesh Lace

6-st repeat

	knit on RS; purl on WS
/	k2tog
\	ssk
o	yo
⅄	sk2p (see Stitch Guide)
	pattern repeat

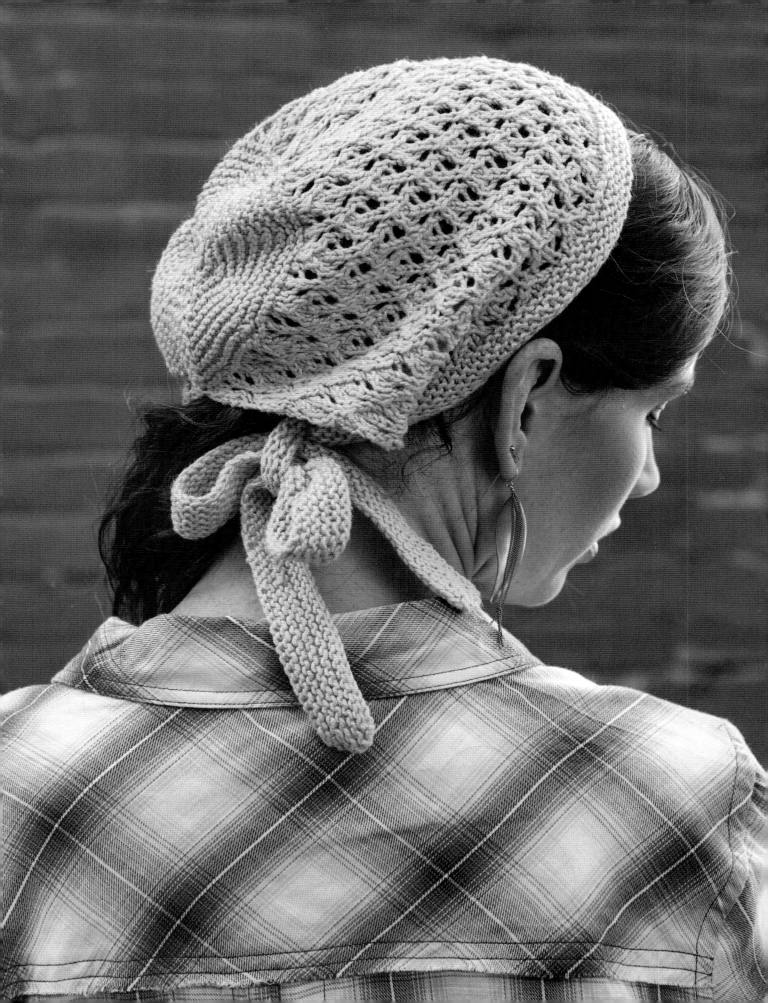

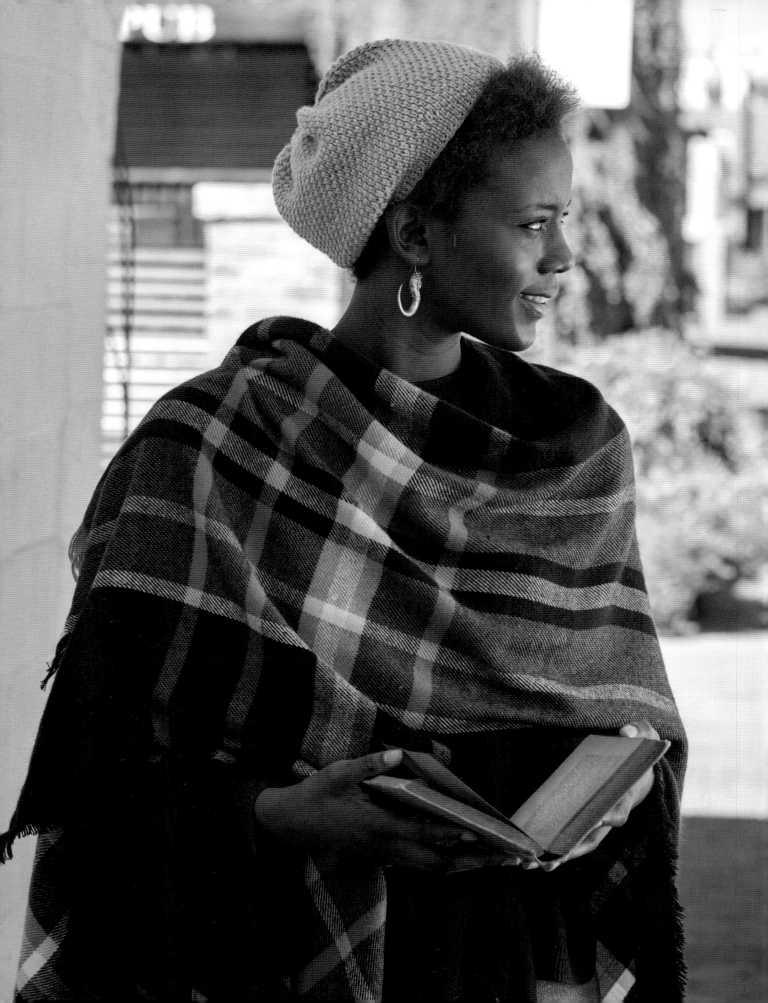

LOCALITY SLIP-STITCH SLOUCH

Designed by *Annie Rowden*

A simple slip-stitch pattern plus a classic neutral equals a timeless topper that will take you through the seasons and all around town. It's worked in a fingering-weight yarn held double for a supple, yet sturdy fabric.

FINISHED SIZE
About 16¼ (18, 19¾)" (41.5 [45.5, 50] cm) circumference at brim and 8" (20.5 cm) tall.

To fit 18¾–20¾ (21–23¼, 23½–25½)" (47.5–52.5 [53.5–59, 59.5–65] cm) head circumference.

Hat shown in 18" (45.5 cm) size.

YARN
Fingering weight (#1 Superfine).

Shown here: A Verb for Keeping Warm Floating (70% alpaca, 20% silk, 10% cashmere; 400 yd [366 m]/100 g); au lait, 1 (1, 2) skein(s).

NEEDLES
Brim
Size U.S. 2 (2.75 mm): 16" (40.5 cm) circular (cir).

Body
Size U.S. 4 (3.5 mm): 16" (40.5 cm) cir and set of 4 or 5 double-pointed (dpn).

Adjust needle sizes if necessary to obtain the correct gauge.

NOTIONS
Marker (m); tapestry needle.

GAUGE
20 sts and 50 rnds = 4" (10 cm) in Slip-Stitch patt on larger needles with 2 strands of yarn.

NOTES
Yarn is held double throughout the pattern.

STITCH GUIDE

S2kp: Slip 2 sts tog as if to k2tog, k1, then pass the 2 slipped sts over the knitted st and off the needle—2 sts dec'd.

K1b: Insert right needle tip from front to back into the st 1 row below the next st on the left needle, wrap the yarn and knit this loop, then slip the st above off the left needle.

K1, P1 Rib in rounds: (even number of sts)

All rnds: *K1, p1; rep from * to end.

Slip-Stitch Pattern: (even number of sts)

Rnd 1: *K1b, k1; rep from * to end.

Rnd 2: Knit.

Rnd 3: *K1, k1b; rep from * to end.

Rnd 4: Knit.

Rep Rnds 1–4 for patt.

BRIM

With smaller cir needle and 2 strands of yarn held together, CO 90 (100, 110) sts using the long-tail method (see Glossary). Place marker (pm) for beg of rnd and join for working in rnds, being careful not to twist sts.

Work in K1, P1 Rib (see Stitch Guide) for 2 rnds.

Next rnd: Knit.

Work in Slip-Stitch patt (see Stitch Guide) until piece meas 1¼" (3.2 cm) from CO edge, ending after Rnd 1 or 3.

BODY

Change to larger cir needle.

Next rnd: (inc) *K10, [k1f&b (see Glossary)] 2 times; rep from * to last 6 (4, 2) sts, knit to end—104 (116, 128) sts. Work in Slip-Stitch patt as established until piece meas 7" (18 cm) from CO edge, ending after Rnd 4.

CROWN

Work crown decreases as follows, changing to dpn when there are too few sts to work comfortably on cir needle.

Rnd 1: *K1b, k1; rep from * to end.

Rnd 2: K4, *s2kp (see Stitch Guide), k5; rep from * to last 4 (0, 4) sts, knit to end—80 (88, 98) sts.

Rnd 3: *K1, k1b; rep from * to end.

Rnd 4: K1, *s2kp, k5; rep from * to last 7 (7, 1) st(s), s2kp 1 (1, 0) time(s), k4 (4, 1)—60 (66, 74) sts.

Rnd 5: *K1b, k1; rep from * to end.

Rnd 6: K4, *s2kp, k5; rep from * to last 0 (6, 6) sts, s2kp 0 (1, 1) time(s), k0 (3, 3)—46 (50, 56) sts.

Rnd 7: *K1, k1b; rep from * to end.

Rnd 8: K1, *s2kp, k5; rep from * to last 5 (1, 7) st(s), s2kp 0 (0, 1) time(s), k5 (1, 4)—36 (38, 42) sts.

Rnd 9: *K1b, k1; rep from * to end.

Rnd 10: K4, *s2kp, k5; rep from * to last 0 (2, 6) sts, s2kp 0 (0, 1) time(s), k0 (2, 3)—28 (30, 32) sts.

Rnd 11: *K1, k1b; rep from * to end.

Rnd 12: *K2tog; rep from * to end—14 (15, 16) sts.

FINISHING

Cut yarn. Thread tail on a tapestry needle, draw through rem sts 2 times, pull tight to close hole, and fasten off on WS. Weave in loose ends and gently steam block (see Glossary).

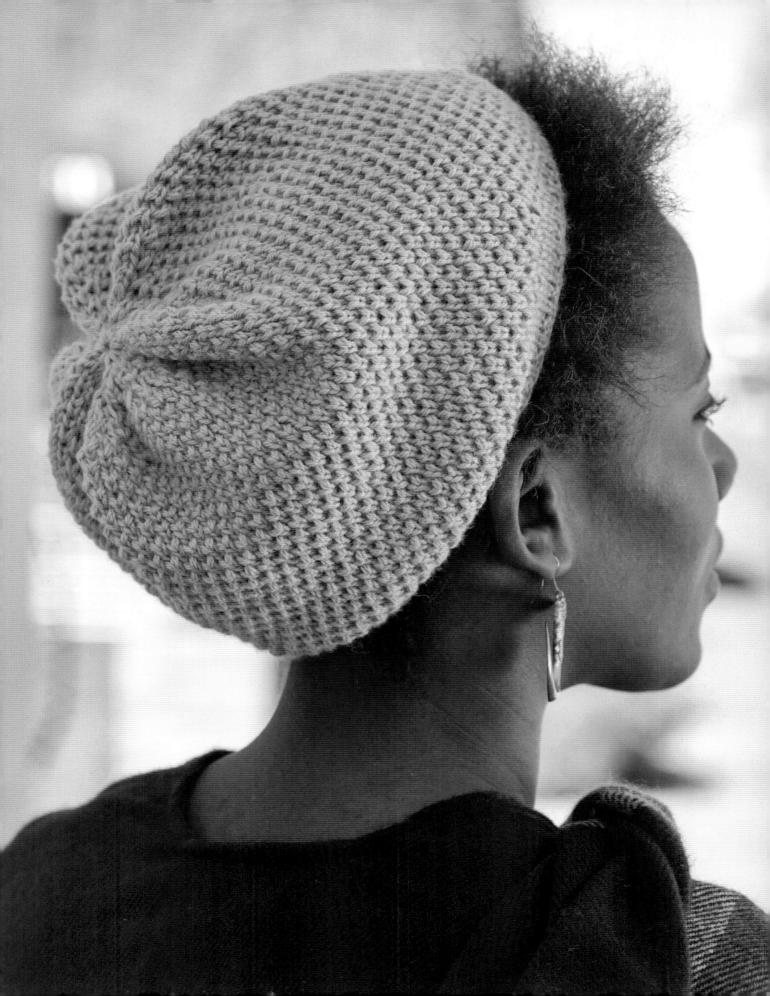

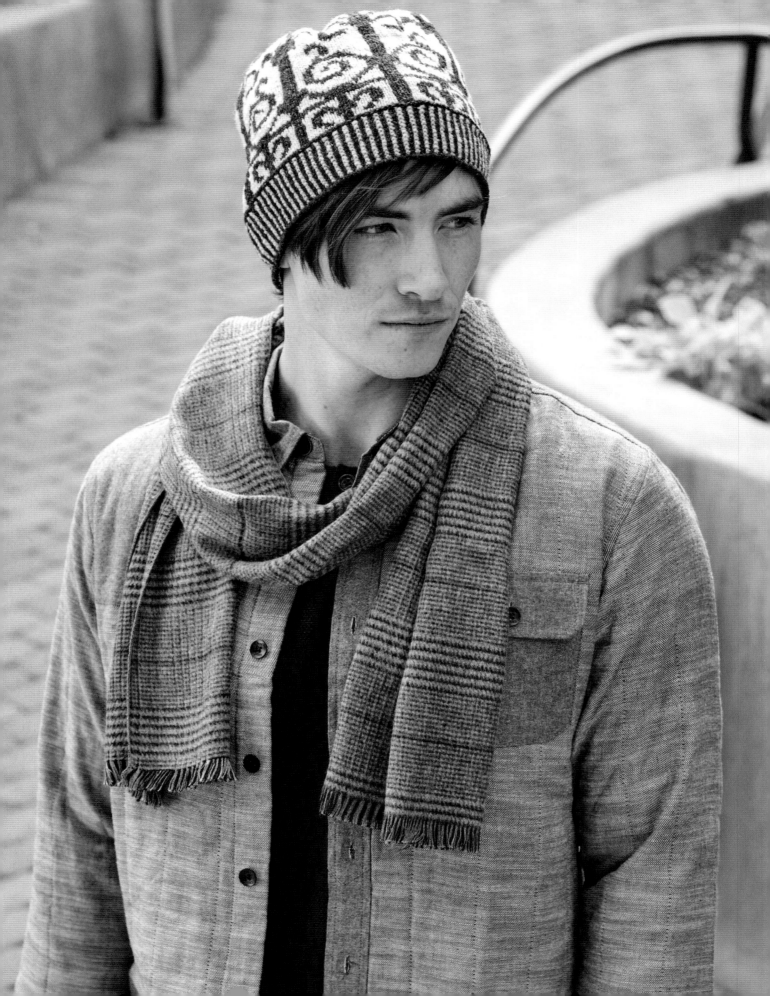

FORGE GRAPHIC TOQUE

Designed by *Meghan Babin*

This striking unisex hat features a bold stranded pattern in contrasting gray and charcoal inspired by wrought-iron designs. A corrugated-rib brim provides the perfect base for the oversized colorwork pattern, and the stranded knitting creates a dense, warm fabric.

FINISHED SIZE

About 19¾" (22)" (50 [56] cm) circumference at brim and 9¼" (23.5 cm) tall.

To fit 20¾–21¾ (21¾–22¾)" (52.5–55 [55–58] cm) head circumference.

Hat shown in 22" (56 cm) size.

YARN

Fingering weight (#1 Superfine).

Shown here: Brooklyn Tweed Loft (100% American wool; 250 yd [229 m]/50 g): cast iron (MC; black) and fossil (CC; white), 1 skein each.

NEEDLES

Brim
Size U.S. 0 (2 mm): 16" (40.5 cm) circular (cir).

Body
Size U.S. 1 (2.25 mm): 16" (40.5 cm) cir and set of 4 or 5 double-pointed (dpn).

Adjust needle sizes if necessary to obtain the correct gauge.

NOTIONS

Marker (m); smooth fingering-weight waste yarn for provisional CO (optional); size B/1 (2.25 mm) crochet hook for provisional CO (optional); tapestry needle.

GAUGE

30 sts and 38 rnds = 4" (10 cm) in Colorwork patt from chart on larger needles.

NOTES

Hat is worked from the bottom up in the round.

An optional tubular cast-on technique is given for an elastic edge.

STITCH GUIDE

Sl 1 wyb: Slip 1 st purlwise with yarn in back.

Tubular CO (optional):

With smaller cir needle, crochet hook, and waste yarn, use a provisional method (see Glossary) to CO 73 (81) sts. Cut waste yarn. Continue with MC as follows:

Row/Rnd 1: Purl.

Rnd 2: *K1, use left needle tip to lift strand between the last knitted stitch and the first stitch on the left needle, then purl the lifted loop; rep from * to last st, place marker (pm) for beg of rnd, k2tog (the first st of Rnd 3 has been worked)—144 (160) sts.

Rnd 3: *K1, sl 1 wyb; rep from * to end.

Rnd 4: *Sl 1 wyb, p1; rep from * to end.

Remove waste yarn.

Corrugated Rib: (even number of sts)

All rnds: *K1 with MC, p1 with CC; rep from * to end.

BODY

Change to larger cir needle.

Next rnd: (inc) With MC only, *k9 (40), M1 (see Glossary); rep from * to end—16 (4) sts inc'd; 160 (164) sts. Work Rnds 1–72 from Colorwork chart, changing to dpn when there are too few sts to work comfortably on cir needle—4 (8) sts.

FINISHING

Cut yarn, leaving an 8" (20.5 cm) tail. Thread tail on a tapestry needle, draw through rem sts, pull tight to close hole, and fasten off on WS. Weave in loose ends. Block to measurements.

BRIM

With smaller cir needle and using tubular method (see Stitch Guide) or long-tail method (see Glossary), CO 144 (160) sts with MC. Place marker (pm) for beg of rnd and join for working in rnds, being careful not to twist sts. Join CC.

Next rnd: (set-up) *K1 with MC, k1 with CC; rep from * to end.

Work in Corrugated Rib (see Stitch Guide) until piece meas 1¾" (4.5 cm) from CO edge.

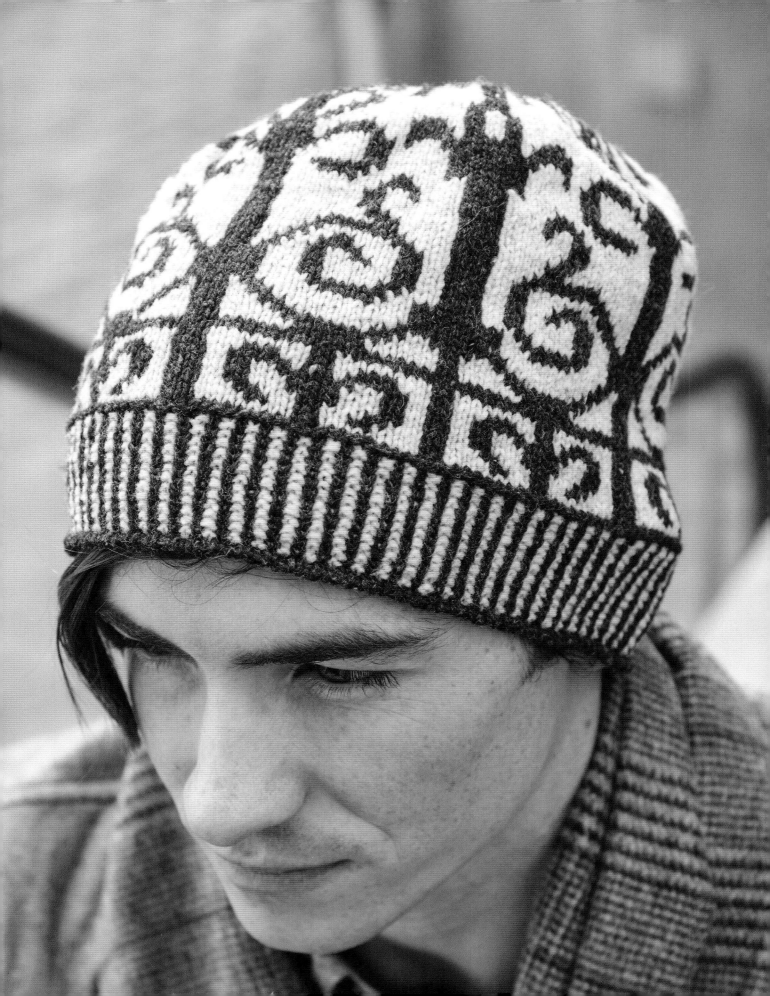

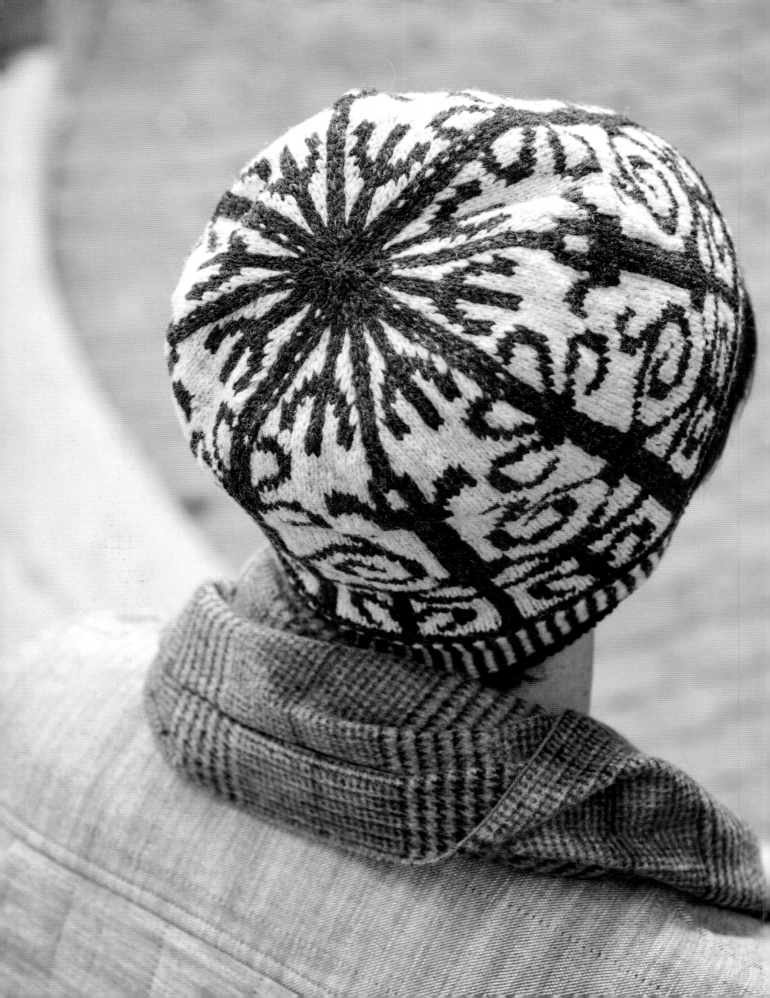

Breaker's Gate

△	knit with MC
·	purl with MC
╱	k2tog with MC
╲	ssk with MC
□	knit with CC
▦	no stitch

71
69
67
65
63
61
59
57
55
53
51
49
47
45
43
41
39
37
35
33
31
29
27
25
23
21
19
17
15
13
11
9
7
5
3
1

end 22" (56 cm)

end 19¾" (50 cm)

40 (41) sts dec'd to 1 (2) st(s)

beg all sizes

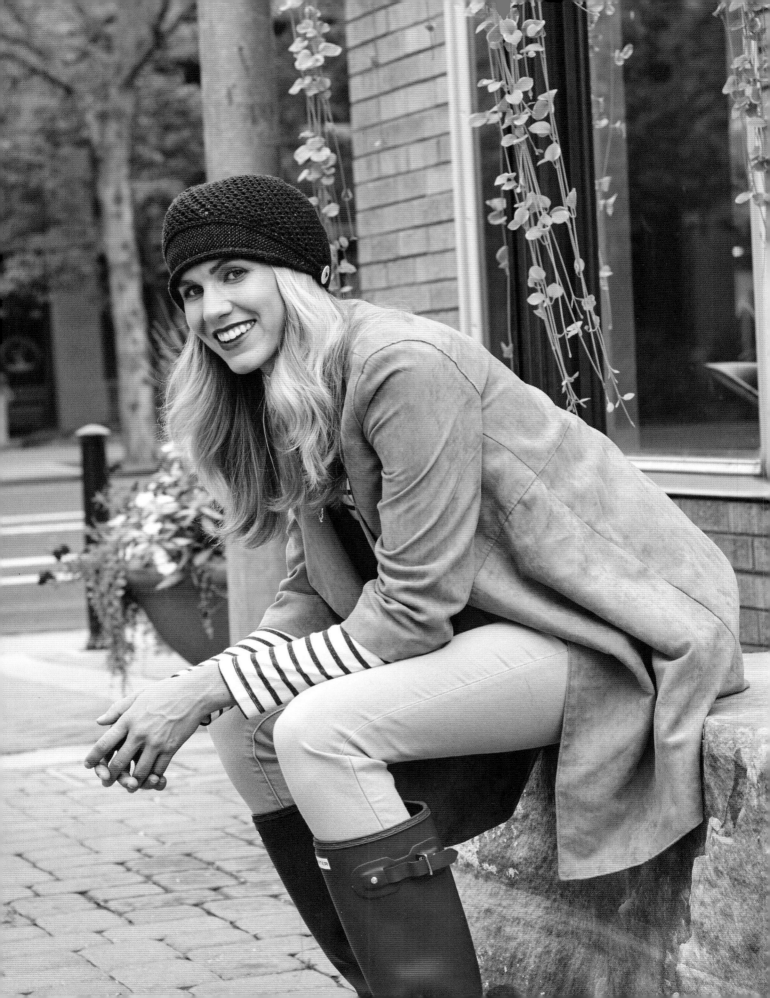

SCOOP BRIMMED CAP

Designed by *Melissa La Barre*

This modern take on a classic newsboy cap is stylishly feminine. The curved band is knit first, and then stitches are picked up along one edge and joined in the round to knit the body of the hat. The airy lace body makes it perfect for transitional weather.

FINISHED SIZE

About 19" (48.5 cm) circumference at brim and 7½" (19 cm) tall without brim.

To fit 20–23" (51–58.5 cm) head circumference.

YARN

Worsted weight (#4 Medium).

Shown here: Dream in Color Classy with Cashmere (70% superwash merino wool, 20% cashmere, 10% nylon; 200 yd [183 m]/113 g): pomagrenade, 1 skein.

NEEDLES

Band
Size U.S. 5 (3.75 mm): straight.

Body
Size U.S. 6 (4 mm): 16" (40.5 cm) circular (cir) and set of 4 or 5 double-pointed (dpn).

Adjust needle sizes if necessary to obtain the correct gauge.

NOTIONS

Removable markers (m); tapestry needle; sewing needle and matching thread; one ⅞" (2.2 cm) button.

GAUGES

21 sts and 28 rows = 4" (10 cm) in St st (knit on RS, purl on WS) on smaller needles.

20 sts and 32 rnds = 4" (10 cm) in Garter Mesh patt on larger needles.

STITCH GUIDE

**Garter Mesh Pattern in rounds:
(even number of sts)**

Rnd 1: *K2tog, yo; rep from * to end.

Rnd 2: Purl.

Rep Rnds 1 and 2 for patt.

BAND

Increases

With smaller needles, CO 5 sts.
Row 1: (RS) K5.
Row 2: (WS) P2, k1, p2.
Row 3: K2, p1f&b (see Glossary), k2—6 sts.
Row 4: P2, k2, p2.
Row 5: K2, purl to last 3 sts, p1f&b, k2—7 sts.
Row 6: P2, knit to last 2 sts, p2.
Rep Rows 5 and 6 nine more times—16 sts.

Straight Section

Row 1: (RS) K2, purl to last 2 sts, k2.
Row 2: P2, knit to last 2 sts, p2.
Rep Rows 1 and 2 until band meas 11" (28 cm) from CO edge.

Decreases

Row 1: (RS) K2, purl to last 3 sts, k2tog, k1—15 sts.
Row 2: P2, knit to last 2 sts, p2.
Rep Rows 1 and 2 ten more times—5 sts.

Straight Section

Row 1: (RS) K2, p1, k2.
Row 2: P2, k1, p2.
Rep Rows 1 and 2 until band meas 19" (48.5 cm) from CO edge. Place removable marker.

Button Tab

Row 1: (buttonhole) K1, k2tog, [yo] 2 times, k2.
Row 2: P2, k1 (knitting the 2 yarnovers as a single stitch), p2.
Row 3: Ssk, p1, k2tog—3 sts.
BO all sts.

BODY

Pick Up Stitches

With cir needle and RS facing, pick up and knit (see Glossary) 96 sts evenly spaced along straight edge of band, at a rate of about 3 sts for every 4 rows, in two sections: the first section begins at the center of the widest straight section of the band toward button tab and ends at the removable marker (so that no sts are picked up along edge above buttonhole); the second section begins at the other end of the band and ends at the center of the widest straight section of the band. Place marker (pm) for beg of rnd and join to work in rnds.

Garter Mesh

Work in Garter Mesh patt (see Stitch Guide) for 4¾" (12 cm), ending after Rnd 1.

CROWN

Next rnd: (set-up) [P24, pm] 3 times, p24.

Work crown decreases as follows, changing to dpn when there are too few sts to work comfortably on cir needle:

Rnd 1: [*K2tog, yo; rep from * to last 4 sts before m, [k2tog] 2 times, slip marker (sl m)] 4 times—8 sts dec'd; 88 sts.

Rnd 2: Purl.

Rep the last 2 rnds 10 more times—8 sts.

FINISHING

Cut yarn. Thread tail on a tapestry needle, draw through rem sts, pull tight to close hole, and fasten off on WS. Weave in loose ends.

Overlap button tab on top of band and use sewing needle and matching thread to sew button through both layers of knitting. Gently wet-block (see Glossary) hat to flatten out band and lay flat to dry.

" Hat Trick

I like to make sure that the ribbed bands of my hats have a few inches of negative ease (meaning they measure a bit smaller than my head circumference). This ensures a snug fit and keeps my hat firmly planted on my head, even on the windiest of days.

—Melissa "

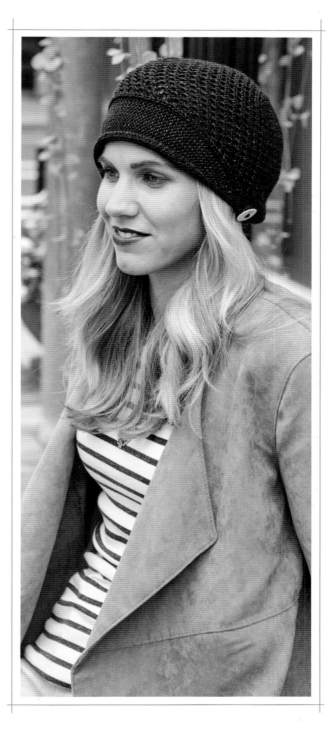

VERDURE BUTTONED CLOCHE

Designed by *Faina Goberstein*

A slip-stitch bow pattern alternates with stockinette to create a fun checkerboard pattern in this flattering chapeau. The spring-green color will add a touch of vibrant freshness to your fall and winter wardrobes.

FINISHED SIZE

About 17¼ (19, 20¾, 22½)" (44 [48.5, 52.5, 57] cm) circumference at band and 9¾" (25 cm) tall.

To fit 18½–20¼ (20½–22¼, 22½–24¼, 24½–26¾)" (47–51.5 [52–56.5, 57–61.5, 62–68] cm) head circumference.

Hat shown in 19" (48.5 cm) size.

YARN

Worsted weight (#4 Medium).

Shown here: Malabrigo Merino Worsted (100% merino wool; 210 yd [192 m]/100 g): #505 moss, 1 (1, 2, 2) skeins.

NEEDLES

Band
Size U.S. 5 (3.75 mm).

Body
Size U.S. 8 (5 mm): 16" (40.5 cm) circular (cir) and set of 4 or 5 double-pointed (dpn).

Adjust needle sizes if necessary to obtain the correct gauge.

NOTIONS

Removable markers (m); tapestry needle; one 1¾" (4.5 cm) button; sewing needle and matching thread.

GAUGE

19½ sts and 36 rnds = 4" (10 cm) in Bows patt on larger needles.

NOTES

The Bows pattern is written for working in the round. For best results, make a gauge swatch in the round.

All slipped stitches in this pattern are slipped purlwise with yarn in front of work.

STITCH GUIDE

Sl 1 wyf: Slip 1 st purlwise with yarn in front.

T4 (tuck stitch): With left needle, catch 4 floats in front of next elongated st, so floats are on top of needle and in front of elongated st (5 loops on needle: 1 live st and 4 floats). Knit all loops tog.

Bows Pattern: (multiple of 10 sts)

Rnds 1, 3, 5, and 7: *Sl 5 wyf, k5; rep from * to end.

Rnds 2, 4, 6, and 8: *P5, k5; rep from * to end.

Rnd 9: *K2, T4, k2, sl 5 wyf; rep from * to end.

Rnds 10, 12, 14, and 16: *K5, p5; rep from * to end.

Rnds 11, 13, and 15: *K5, sl 5 wyf; rep from * to end.

Rnd 17: *K7, T4, k2; rep from * to end.

Rep Rnds 1–17 for patt.

BAND

With smaller needles, CO 3 sts. Work Rows 1–15 from instructions below or from Band chart.

Row 1: (RS) Sl 1 wyf, k2.
Row 2: Rep Row 1.
Row 3: Sl 1 wyf, M1 (see Glossary), p1, M1, k1—5 sts.
Row 4: Sl 1 wyf, [p1, k1] 2 times.
Row 5: Sl 1 wyf, M1, k1, p1, k1, M1, k1—7 sts.
Row 6: Sl 1 wyf, [k1, p1] 2 times, k2.
Row 7: Sl 1 wyf, M1, [p1, k1] 2 times, p1, M1, k1—9 sts.
Row 8: Sl 1 wyf, [p1, k1] 4 times.
Row 9: Sl 1 wyf, M1, [k1, p1] 3 times, k1, M1, k1—11 sts.
Row 10: Sl 1 wyf, [k1, p1] 4 times, k2.
Row 11: Sl 1 wyf, M1, [p1, k1] 2 times, k1, [k1, p1] 2 times, M1, k1—13 sts.
Row 12: Sl 1 wyf, [p1, k1] 2 times, k3, [k1, p1] 2 times, k1.
Row 13: Sl 1 wyf, [k1, p1] 2 times, M1, k3, M1, [p1, k1] 2 times, k1—15 sts.
Row 14: Sl 1 wyf, [p1, k1] 2 times, k5, [k1, p1] 2 times, k1.
Row 15: Sl 1 wyf, [k1, p1] 2 times, k5, [p1, k1] 2 times, k1.
Rep Rows 14 and 15 until piece meas about 18¾ (20½, 22¼, 24)" (47.5 [52, 56.5, 61] cm) from CO edge. Cut yarn, leaving a 12" (30.5 cm) tail for sewing later. Do not BO sts.

Place removable marker 1½" (3.8 cm) from CO edge to mark button tab and placement of seam. With RS facing and CO edge at right, fold band to make a circle, making sure not to twist band and overlapping button tab on top of band. Sew live sts to WS of band at marker using backstitch (see Glossary).
Band circumference is 17¼ (19, 20¾, 22½)" (44 [48.5, 52.5, 57] cm). With RS facing and button tab oriented toward the right, fold the band at the point diametrically opposite seam. This divides the band into front and back portions. Place removable marker at center back to mark beg of rnd for body.

BODY

With RS facing and larger cir needle, join yarn at beg-of-rnd marker. Pick up and knit (see Glossary) 100 (110, 120, 130) sts evenly spaced along top edge of band, working into the back of the sts below the selvedge. Join for working in rnds.
Next rnd: Knit.
Work even in Bows patt from Stitch Guide or chart until hat meas about 6¾" (17 cm) from bottom edge of band, ending after Rnd 9 of Bows patt.

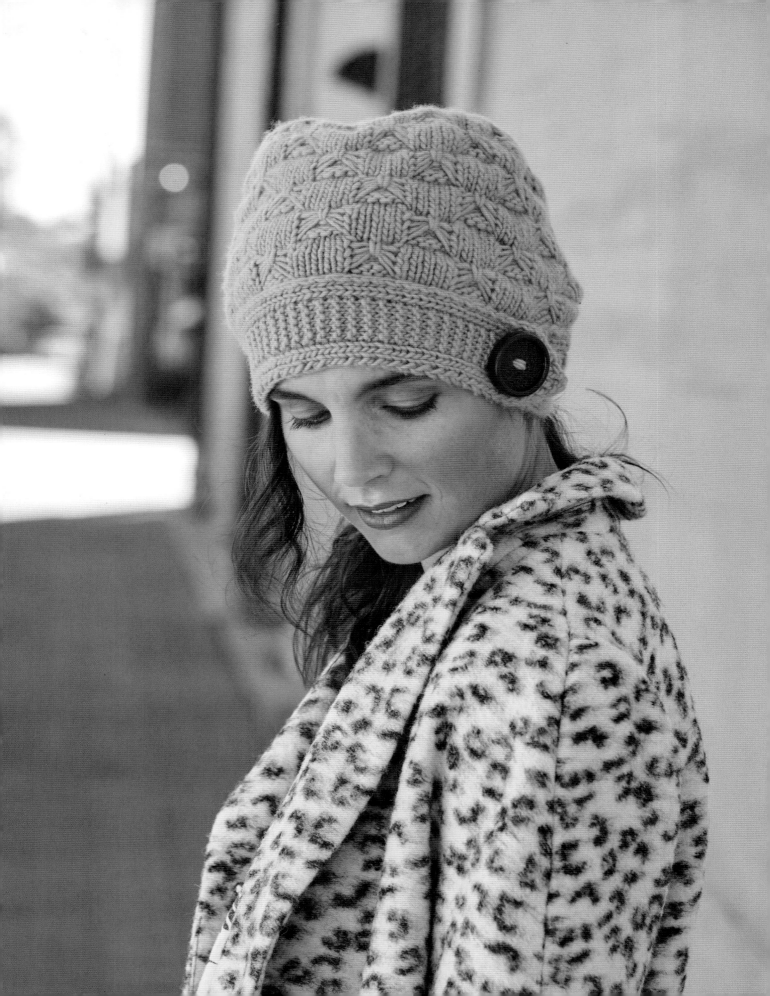

CROWN

Work crown decreases as follows, changing to dpn when there are too few sts to work comfortably on cir needle.

Rnd 1: *K5, p2tog, p3; rep from * to end—90 (99, 108, 117) sts.

Rnds 2 and 4: *K5, sl 4 wyf; rep from * to end.

Rnd 3: *K5, p4; rep from * to end.

Rnd 5: *K5, p2, p2tog; rep from * to end—80 (88, 96, 104) sts.

Rnd 6: *K5, sl 3 wyf; rep from * to end.

Rnd 7: *K5, p3; rep from * to end.

Rnd 8: *Sl 5 wyf, k1, T4, k1; rep from * to end.

Rnd 9: *P2tog, p3, k3; rep from * to end—70 (77, 84, 91) sts.

Rnds 10 and 12: *Sl 4 wyf, k3; rep from * to end.

Rnd 11: *P4, k3; rep from * to end.

Rnd 13: *P2, p2tog, k3; rep from * to end—60 (66, 72, 78) sts.

Rnd 14: *Sl 3 wyf, k3; rep from * to end.

Rnd 15: *P3, k3; rep from * to end.

Rnd 16: *K1, T4, k1, p2tog, p1; rep from * to end—50 (55, 60, 65) sts.

Rnd 17: *K3, p2; rep from * to end.

Rnd 18: *K1, k2tog, p2; rep from * to end—40 (44, 48, 52) sts.

Rnd 19: *K2, p2; rep from * to end.

Rnd 20: *K2, p2tog; rep from * to end—30 (33, 36, 39) sts.

Rnd 21: *K2, p1; rep from * to end.

Rnd 22: *K1, k2tog; rep from * to end—20 (22, 24, 26) sts.

Rnd 23: Knit.

Rnd 24: *K2tog; rep from * to end—10 (11, 12, 13) sts.

Rnd 25: Knit.

FINISHING

Cut yarn. Thread tail on a tapestry needle, draw through rem sts, pull tight to close hole, and fasten off on WS. Weave in loose ends. Sew button to band.

Body

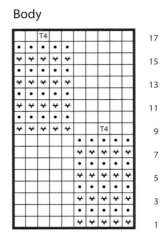

10-st repeat

Band

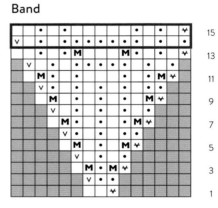

3 sts inc'd to 15 sts

☐	knit on RS; purl on WS
•	purl on RS; knit on WS
�	sl 1 wyf on RS; sl 1 wyb on WS
V	sl 1 wyb on RS; sl 1 wyf on WS
M	M1
T	T4 (see Stitch Guide)
☐	pattern repeat
▨	no stitch

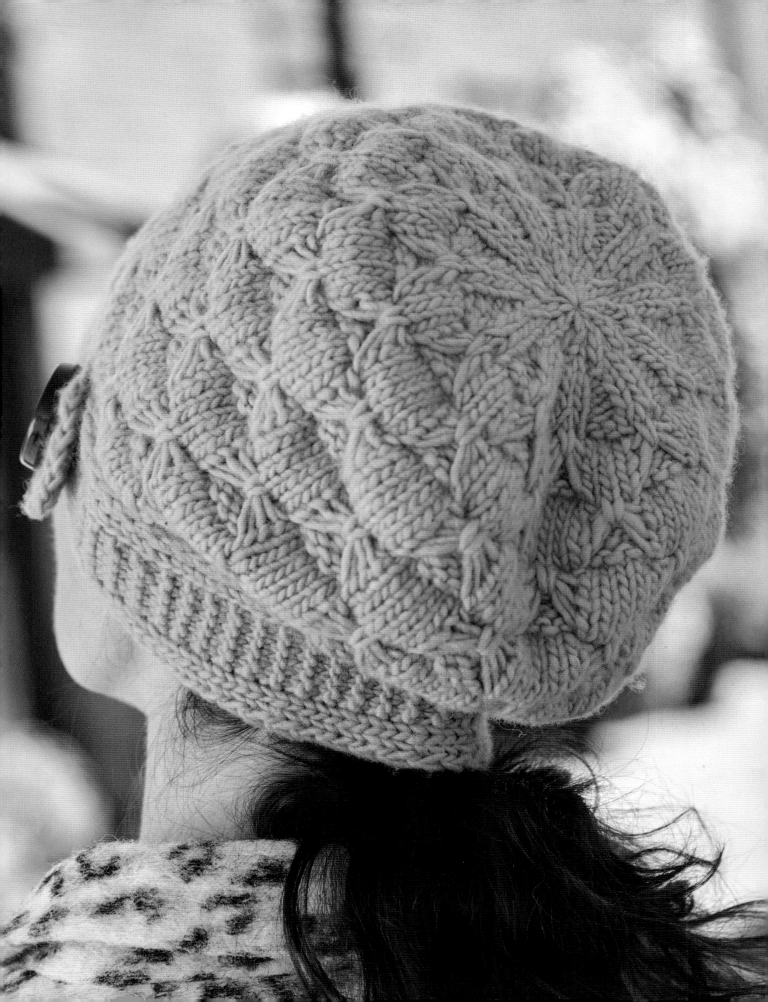

GEM TEXTURED SLOUCH

Designed by *Rachel Coopey*

The ribbed brim of this jewel-tone hat diverges into a meandering faux cable and lace pattern that resolves into a ribbed crown. Add a pom-pom to give it even more sparkle.

FINISHED SIZE

About 19 (20¾, 22½)" (48.5 [52.5, 57] cm) circumference at brim and 9¼" (23.5 cm) tall.

To fit 20–21 (21½–23, 23½–25)" (51–53.5 [54.5–58.5, 59.5–63.5] cm) head circumference.

Hat shown in 20¾" (52.5 cm) size.

YARN

Fingering weight (#1 Superfine).

Shown here: Tanis Fiber Arts Blue Label Fingering Weight (80% superwash merino wool, 20% nylon; 420 yd [384 m]/115 g): garnet, 1 skein.

NEEDLES

Brim
Size U.S. 1½ (2.5 mm): 16" (40.5 cm) circular (cir) or set of 4 or 5 double-pointed (dpn).

Body
Size U.S. 2½ (3 mm): 16" (40.5 cm) cir and set of 4 or 5 dpn.

Adjust needle sizes if necessary to obtain the correct gauge.

NOTIONS

Marker (m); tapestry needle.

GAUGES

37 sts and 46½ rnds = 4" (10 cm) in P2, K2 Rib on smaller needles.

48 sts and 25 rnds = 5¼" (13.5 cm) wide and 2¼" (5.5 cm) tall in Body patt on larger needles.

STITCH GUIDE

P2, K2 Rib in rounds: (multiple of 4 sts)

All rnds: *P2, k2; rep from * to end.

Body Pattern: (multiple of 16 sts)

Rnd 1: *P2, k2, p1, k2tog, k1, yo, p2, yo, k1, ssk, p1, k2; rep from * to end.

Rnd 2: *P2, k2, p1, k8, p1, k2; rep from * to end.

Rnd 3: *P2, k2, k2tog, k1, yo, p4, yo, k1, ssk, k2; rep from * to end.

Rnd 4: *P2, k14; rep from * to end.

Rnd 5: *P2, k1, k2tog, k1, yo, p6, yo, k1, ssk, k1; rep from * to end.

Rnd 6: *P2, k14; rep from * to end.

Rnd 7: *P2, k2tog, k1, yo, p8, yo, k1, ssk; rep from * to end.

Rnds 8–13: *[P2, k2] 4 times; rep from * to end.

Rnd 14: *P2, yo, k1, ssk, p1, k2, p2, k2, p1, k2tog, k1, yo; rep from * to end.

Rnd 15: *K5, p1, k2, p2, k2, p1, k3; rep from * to end.

Rnd 16: *P3, yo, k1, ssk, k2, p2, k2, k2tog, k1, yo, p1; rep from * to end.

Rnd 17: *K8, p2, k6; rep from * to end.

Rnd 18: *P4, yo, k1, ssk, k1, p2, k1, k2tog, k1, yo, p2; rep from * to end.

Rnd 19: *K8, p2, k6; rep from * to end.

Rnd 20: *P5, yo, k1, ssk, p2, k2tog, k1, yo, p3; rep from * to end.

Rnds 21–25: *[P2, k2] 4 times; rep from * to end.

Crown Pattern: (16 sts dec'd to 1)

Rnd 1: *P2, k2; rep from * to end.

Rnd 2: *[P2, k2] 3 times, p1, k2tog, k1; rep from * to end.

Rnd 3: *[P2, k2] 3 times, p1, k2; rep from * to end.

Rnd 4: *[P2, k2] 3 times, k2tog, k1; rep from * to end.

Rnd 5: *[P2, k2] 3 times, k2; rep from * to end.

Rnd 6: *[P2, k2] 2 times, p2, k1, k2tog, k1; rep from * to end.

Rnd 7: *[P2, k2] 3 times, k1; rep from * to end.

Rnd 8: *[P2, k2] 2 times, p2, k2tog, k1; rep from * to end.

Rnd 9: *P2, k2; rep from * to end.

Rnd 10: *[P2, k2] 2 times, p1, k2tog, k1; rep from * to end.

Rnd 11: *[P2, k2] 2 times, p1, k2; rep from * to end.

Rnd 12: *[P2, k2] 2 times, k2tog, k1; rep from * to end.

Rnd 13: *[P2, k2] 2 times, k2; rep from * to end.

Rnd 14: *P2, k2, p2, k1, k2tog, k1; rep from * to end.

Rnd 15: *[P2, k2] 2 times, k1; rep from * to end.

Rnd 16: *P2, k2, p2, k2tog, k1; rep from * to end.

Rnd 17: *P2, k2; rep from * to end.

Rnd 18: *P2, k2, p1, k2tog, k1; rep from * to end.

Rnd 19: *P2, k2, p1, k2; rep from * to end.

Rnd 20: *P2, k2, k2tog, k1; rep from * to end.

Rnd 21: *P2, k4; rep from * to end.

Rnd 22: *P2, k1, k2tog, k1; rep from * to end.

Rnd 23: *P2, k3; rep from * to end.

Rnd 24: *P2, k2tog, k1; rep from * to end.

Rnd 25: *P2, k2; rep from * to end.

Rnd 26: *P1, k2tog, k1; rep from * to end.

Rnd 27: *P1, k2; rep from * to end.

Rnd 28: *K2tog, k1; rep from * to end.

Rnd 29: *Ssk; rep from * to end.

BRIM

With smaller cir needle or dpn, CO 176 (192, 208) sts. Place marker (pm) for beg of rnd and join for working in rnds, being careful not to twist sts.
Work in P2, K2 Rib (see Stitch Guide) for 16 rnds.

BODY

Change to larger cir needle.
Work Rnds 1–25 of Body patt from Stitch Guide or chart once, then work Rnds 1–7 once more.
Work in P2, K2 Rib for 24 rnds.

CROWN

Change to dpn when there are too few sts to work comfortably on cir needle.
Work Rnds 1–29 of Crown patt from Stitch Guide or chart once—11 (12, 13) sts.

FINISHING

Cut yarn, leaving a 6" (15 cm) tail. Thread tail on a tapestry needle, draw through rem sts, pull tight to close hole, and fasten off on WS. Weave in loose ends. Block.

" A Designer's Yarn

I once designed a hat that I very diligently swatched for. As I was knitting it I had an inkling it looked bigger than it should be but I trusted the swatch, carried on, and hoped for the best. The best was not what happened; when the hat came off the needles it was comically large. I love a slouchy hat but this was too much—even for me. I had to reknit the whole thing. Then I cut the lying, deceitful swatch into tiny pieces.

—Rachel "

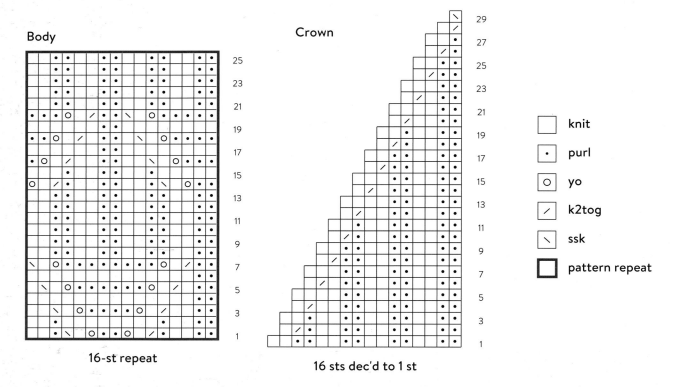

Body
16-st repeat

Crown
16 sts dec'd to 1 st

□ knit
· purl
Ⓞ yo
╱ k2tog
╲ ssk
□ pattern repeat

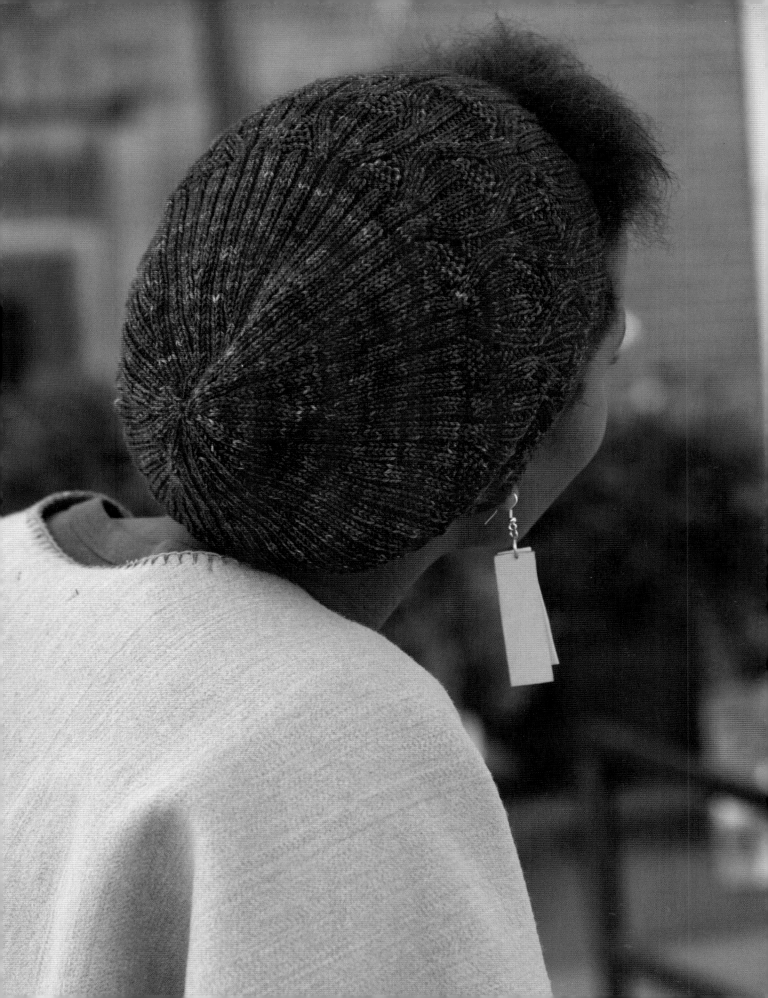

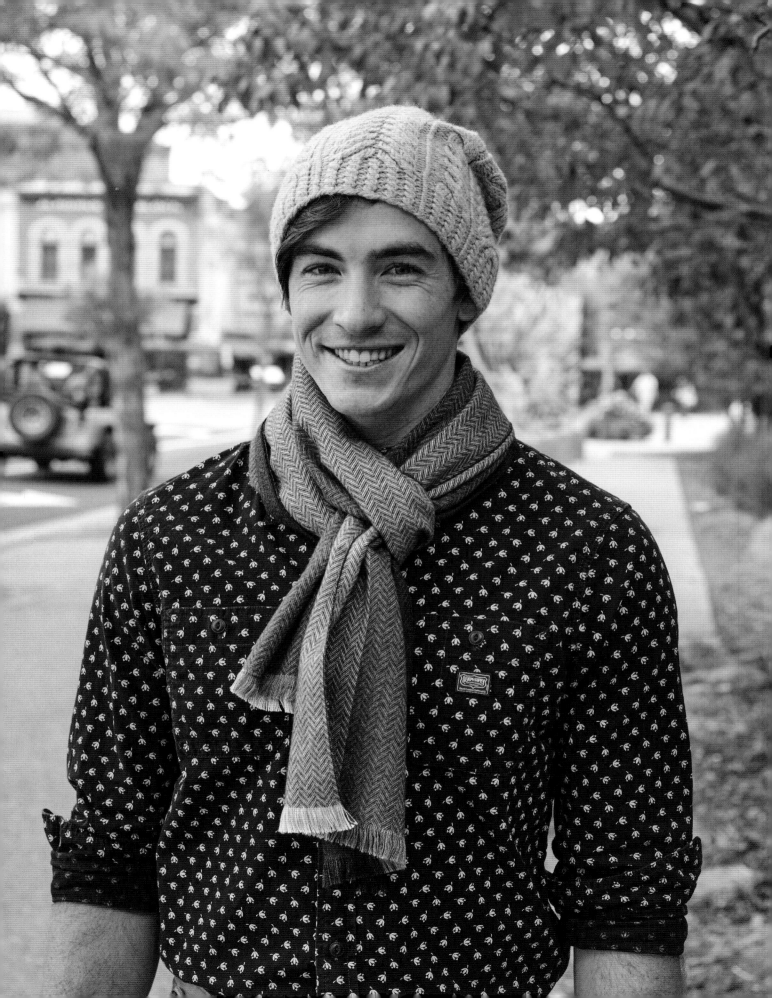

TIMBER CABLED TOQUE

Designed by *Meghan Babin*

Channel your inner woodsman (or woman) in this handsome rustic topper. Cables upon cables flow from the brim to the crown. If you're new to cable knitting, you'll get plenty of practice with these meandering stitches.

FINISHED SIZE

About 20" (51 cm) circumference at brim and 10" (25.5 cm) tall.

To fit 20–21" (51–53.5 cm) head circumference.

YARN

Worsted weight (#4 Medium).

Shown here: Stonehedge Fiber Mill Shepherd's Wool Worsted (100% merino wool; 250 yd [229 m]/100 g): beaches, 1 skein.

NEEDLES

Brim
Size U.S. 6 (4 mm): 16" (40.5 cm) circular (cir).

Body
Size U.S. 8 (5 mm): 16" (40.5 cm) cir and set of 4 or 5 double-pointed (dpn).

Adjust needle sizes if necessary to obtain the correct gauge.

NOTIONS

Marker (m); cable needle (cn); tapestry needle.

GAUGE

26 sts and 31 rnds = 4" (10 cm) in Body patt from chart on larger needles.

NOTE

This pattern is worked from the bottom up in the round from charts.

STITCH GUIDE

K1tbl: Knit 1 st through back loop.

1/1 LC: Sl 1 st onto cn and hold in front, k1, k1 from cn.

1/1 RC: Sl 1 st onto cn and hold in back, k1, k1 from cn.

2/1 LC: Sl 2 sts onto cn and hold in front, k1, k2 from cn.

2/1 RC: Sl 1 st onto cn and hold in back, k2, k1 from cn.

2/2 LC: Sl 2 sts onto cn and hold in front, k2, k2 from cn.

2/2 RC: Sl 2 sts onto cn and hold in back, k2, k2 from cn.

4/4 LC: Sl 4 sts onto cn and hold in front, k4, k4 from cn.

2/2 LCdec: Sl 2 sts onto cn and hold in front, k2tog, k2 from cn—1 st dec'd.

2/2 RCdec: Sl 2 sts onto cn and hold in back, k2, k2tog from cn—1 st dec'd.

2/3 LCdec: Sl 2 sts onto cn and hold in front, k2tog, k1, then k2 from cn—1 st dec'd.

3/2 RCdec: Sl 3 sts onto cn and hold in back, k2, then k2tog, k1 from cn—1 st dec'd.

BRIM

With smaller cir needle, CO 112 sts using the long-tail method (see Glossary). Place marker (pm) for beg of rnd and join for working in rnds, being careful not to twist sts.
Work set-up rnd from Brim chart.
Rep Rnds 1 and 2 from Brim chart until piece meas 1½" (3.8 cm), ending after Rnd 2.
Work Rnds 3 and 4 from Brim chart once—120 sts.

BODY

Change to larger cir needle and work Rnds 1–12 from Body chart 4 times. Piece meas about 8" (20.5 cm) from CO edge.

CROWN

Changing to dpn when there are too few sts to work comfortably on cir needle, work Rnds 1–16 from Crown chart once—8 sts.

FINISHING

Cut yarn, leaving a long tail. Thread tail on a tapestry needle, draw through rem sts, pull tight to close hole, and fasten off on WS. Weave in loose ends. Block to measurements.

" Hat Trick

Fitting hats correctly has always been my Achilles' heel, both as a beginning knitter and as a designer. If the gauge isn't just right, the hat will either squeeze your head or fall down to your nose when least expected. So always be sure to swatch and get gauge!

—*Meghan* "

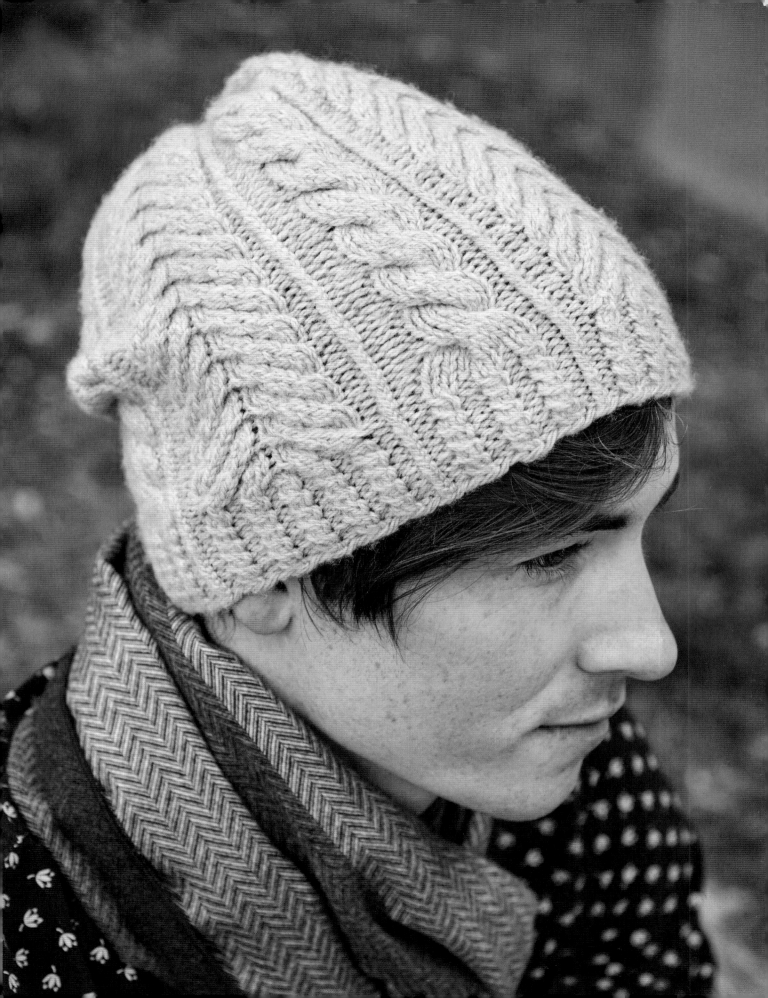

Crown

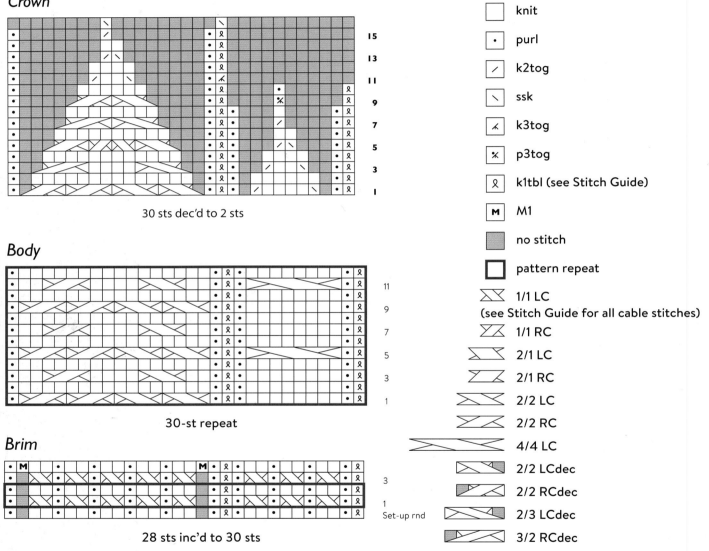

30 sts dec'd to 2 sts

Body

30-st repeat

Brim

28 sts inc'd to 30 sts

☐	knit	
•	purl	
╱	k2tog	
╲	ssk	
⋏	k3tog	
⋇	p3tog	
ℓ	k1tbl (see Stitch Guide)	
M	M1	
▨	no stitch	
☐	pattern repeat	
	1/1 LC	
	(see Stitch Guide for all cable stitches)	
	1/1 RC	
	2/1 LC	
	2/1 RC	
	2/2 LC	
	2/2 RC	
	4/4 LC	
	2/2 LCdec	
	2/2 RCdec	
	2/3 LCdec	
	3/2 RCdec	

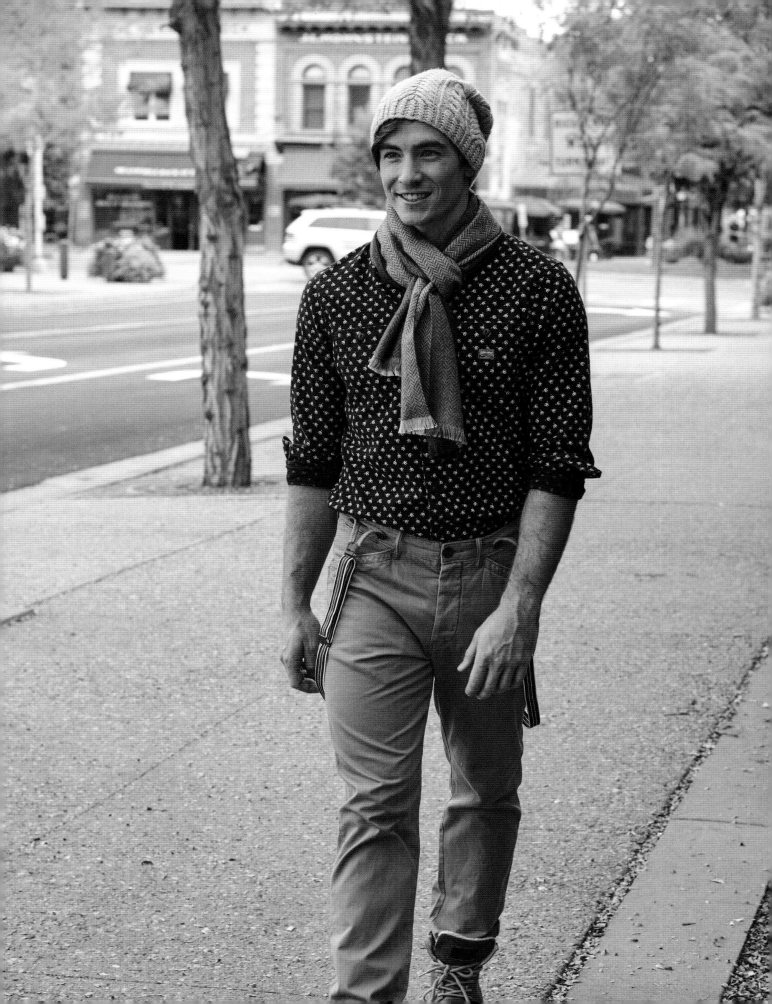

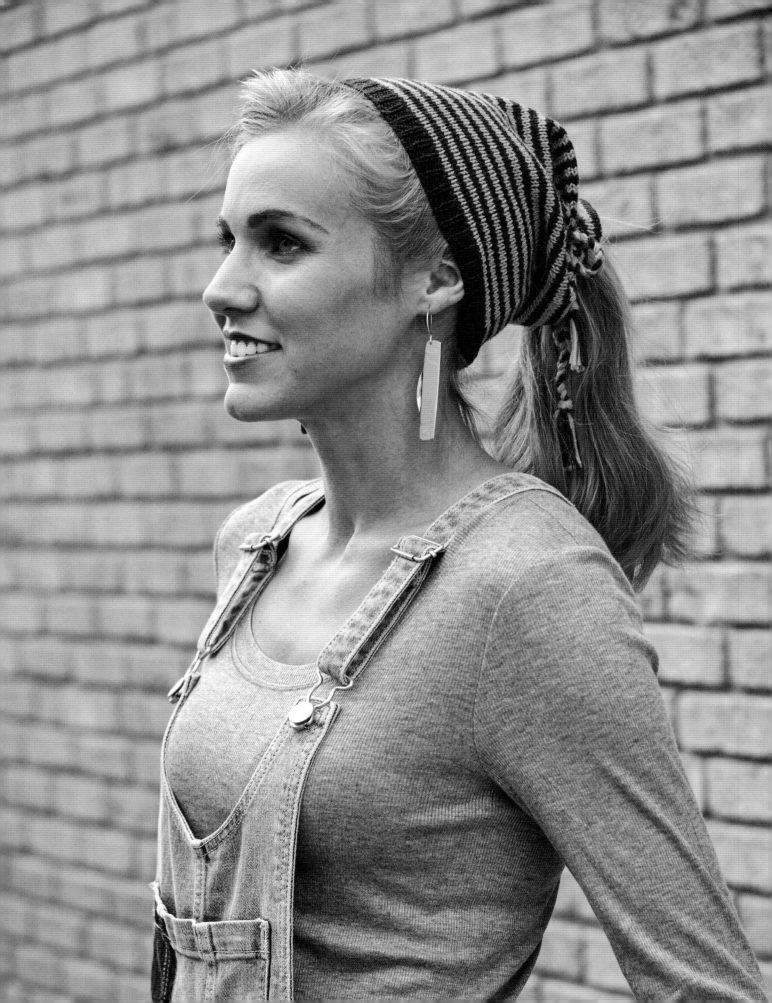

FROLIC PAPERBAG HAT

Designed by *Alexis Winslow*

This whimsical striped topper is fun and easy to make—perfect for a beginning knitter or a satisfying project for a knitter at any level. Complementary colors and a tasseled drawstring add to the irreverent effect. Wear it with or without a ponytail through the gathered opening.

FINISHED SIZE

About 18 (19½)" (45.5 [49.5] cm) circumference at brim and 9¼ (10½)" (23.5 [26.5] cm) tall.

To fit 18½–20 (20–21½)" (47–51 [51–54.5] cm) head circumference.

Hat shown in 18" (45.5 cm) size.

YARN

Fingering weight (#1 Superfine).

Shown here: Quince & Co. Finch (100% wool; 221 yd [202 m]/50 g); #133 winesap (red; A) and #139 Belize (blue; B), 1 skein each.

NEEDLES

Brim
Size U.S. 4 (3.5 mm): straight.

Body
Size U.S. 5 (3.75 mm): straight.

Adjust needle sizes if necessary to obtain the correct gauge.

NOTIONS

Tapestry needle.

GAUGE

24½ sts and 40 rows = 4" (10 cm) in St st on larger needles.

STITCH GUIDE

K1, P1 Rib in rows: (even number of sts)

All rows: *K1, p1; rep from * to end.

Stripe Pattern:

Row 1: (RS) Knit with B.

Row 2: Purl with B.

Row 3: Knit with A.

Row 4: Purl with A.

Rep Rows 1–4 for patt.

Tip: When switching colors between rows, loosely twist the two colors together once and carry the unused color loosely up the wrong side of work until it is needed again.

BRIM

With smaller needles and A, use the long-tail method (see Glossary) to CO 112 (122) sts.
Work in K1, P1 Rib (see Stitch Guide) for 7 rows.

BODY

Change to larger needles.
Next row: (RS) Knit with A.
Next row: Purl with A.
Work in Stripe patt (see Stitch Guide) until piece meas 8¼ (9½)" (21 [24 cm]) from CO edge, ending after row 4 of Stripe patt.
Next row: (eyelet—RS) With B, k5, *yo, k2tog, k9 (10); rep from * to last 8 (9) sts, yo, k2tog, k6 (7)—10 eyelets.
Next row: Purl with B.
Work Rows 3 and 4 of Stripe patt once, then work in Stripe patt for 4 rows.
With B, work in St st (knit on RS, purl on WS) for 6 rows.
Loosely BO all sts.

FINISHING

Block hat.
Starting at brim, use mattress stitch (see Glossary) to sew back edges of hat together, being careful to match stripes.
Turn hat inside out and fold last 6 rows of St st in B in half for a 6-row hem.
With B threaded on a tapestry needle, whipstitch (see Glossary) the hem in place invisibly on WS just above the eyelet row, being careful not to let stitches show on RS. Weave in loose ends.

Make Cord and Tassels

Cut 10 strands of B and 5 strands of A, each 40" (101.5 cm) long. Line up the ends and tie an overhand knot 2¼" (5.5 cm) from one end. Organize the strands into three equal groups: one group in A and two groups in B. Neatly braid the groups of strands together to the last 3" (7.5 cm). Tie an overhand knot at end. Trim the tassels at the ends of the braid to equal lengths. Thread braid through eyelets, starting at back seam. Cinch the top of the hat together and tie a bow or a loose knot with the cord.

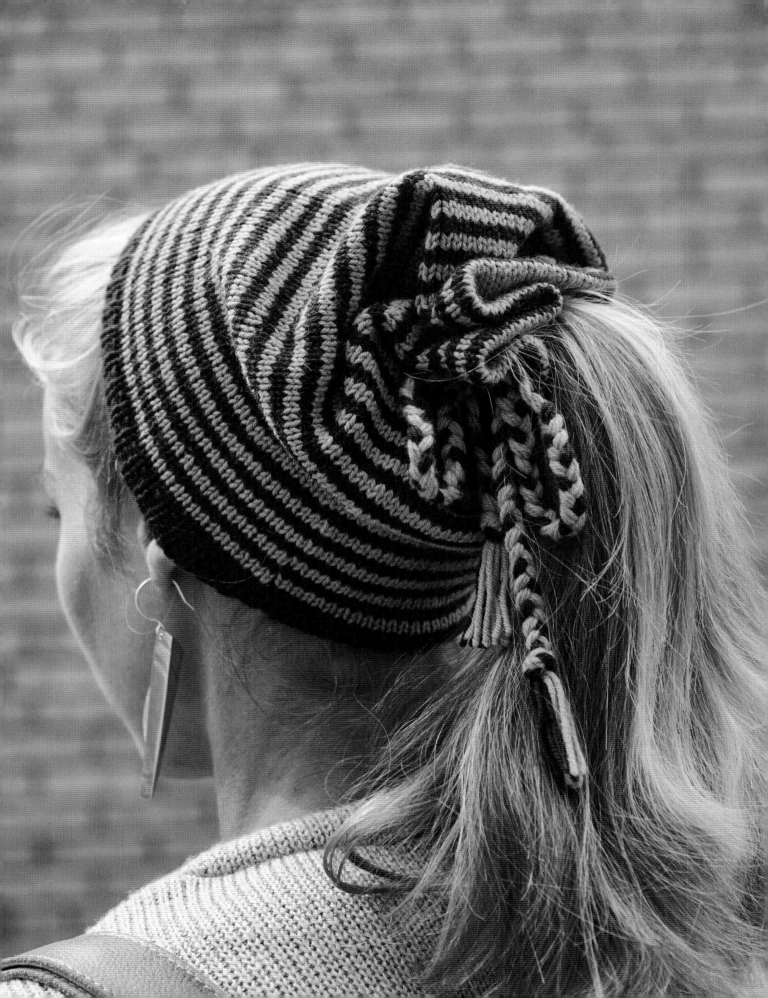

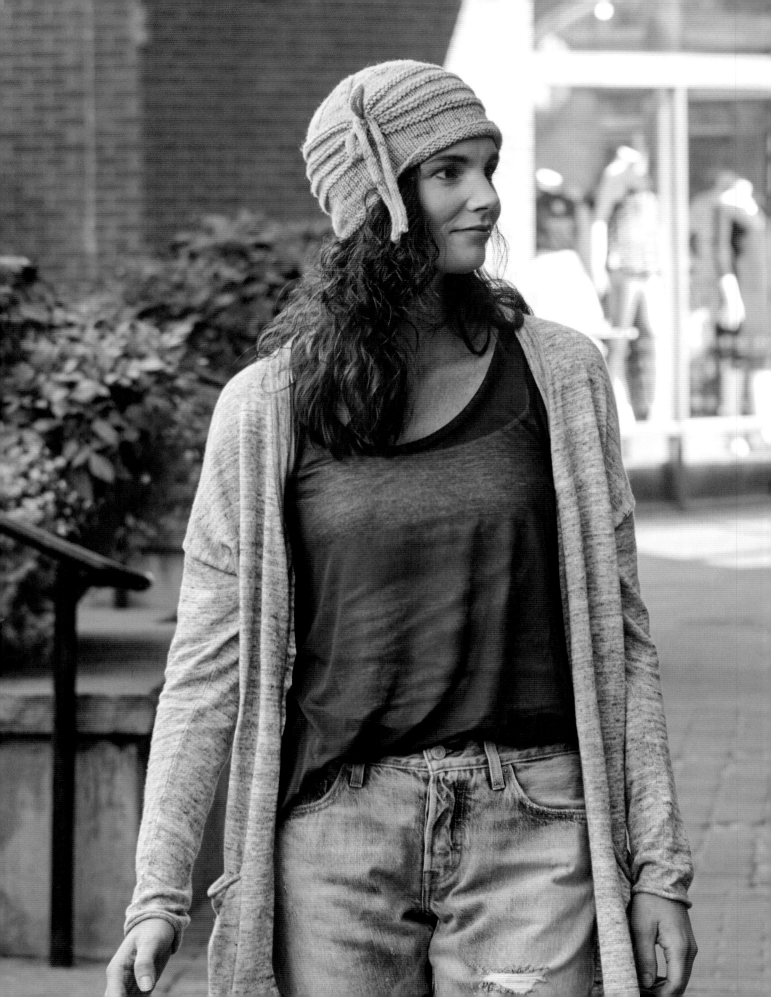

FLAPPER RIDGED CLOCHE

Designed by *Tanis Gray*

You'll feel like dancing in this fetching cap. Alternating sections of knit and purl rows create a welted fabric. The hat is slightly gathered after knitting and adorned with an I-cord bow.

FINISHED SIZE

About 20½" (52 cm) circumference at brim and 8½" (21.5 cm) tall.

To fit 20½–22" (52–56 cm) head circumference.

YARN

DK weight (#3 Light).

Shown here: Dragonfly Fibers Traveller (100% superwash merino wool; 280 yd [256 m]/113 g): Cheshire cat, 1 skein.

NEEDLES

Size U.S. 6 (4 mm): 16" (40.5 cm) circular (cir) and set of 4 or 5 double-pointed (dpn).

Adjust needle size if necessary to obtain the correct gauge.

NOTIONS

Marker (m); tapestry needle.

GAUGE

19½ sts and 32 rnds = 4" (10 cm) in St st.

STITCH GUIDE

Ridge Pattern:

Rnd 1: Purl.

Rnd 2: Knit.

Rnd 3: Purl.

Rnds 4–8: Knit.

Rep Rnds 1–8 for patt.

BRIM

With cir, CO 99 sts. Place marker (pm) for beg of rnd and join for working in rnds, being careful not to twist sts.

Rnd 1: Knit.

Rnd 2: Purl.

Rep the last 2 rnds once.

Work even in St st (knit every rnd) for 2" (5 cm).

BODY

Work Rnds 1–8 of Ridge patt (see Stitch Guide) 4 times. Work even in St st for 3 rnds.

CROWN

Work crown decreases as follows, changing to dpn when there are too few sts to work comfortably on cir needle.

Rnd 1: *K2tog, k9; rep from * to end—90 sts.

Rnd 2 and all even-numbered rnds: Knit.

Rnd 3: *K2tog, k8; rep from * to end—81 sts.

Rnd 5: *K2tog, k7; rep from * to end—72 sts.

Rnd 7: *K2tog, k6; rep from * to end—63 sts.

Rnd 9: *K2tog, k5; rep from * to end—54 sts.

Rnd 11: *K2tog, k4; rep from * to end—45 sts.

Rnd 13: *K2tog, k3; rep from * to end—36 sts.

Rnd 15: *K2tog, k2; rep from * to end—27 sts.

Rnd 17: *K2tog, k1; rep from * to end—18 sts.

Rnd 19: *K2tog; rep from * to end—9 sts.

FINISHING

Cut yarn, leaving a 12" (30.5 cm) tail. Thread tail on a tapestry needle, draw through rem sts, pull tight to close hole, and fasten off on WS.

*With dpn, pick up and knit (see Glossary) 1 st between Rnds 1 and 3 of each Ridge repeat at beg-of-rnd edge—4 sts. This will gather the sts. Work 4-st I-cord (see Glossary) for 13" (33 cm). BO all sts and weave in loose ends.

Rep from * about ¼" (6 mm) next to first cord to create second cord.

Weave in loose ends. Block lightly.

Tie I-cords with an overhand knot.

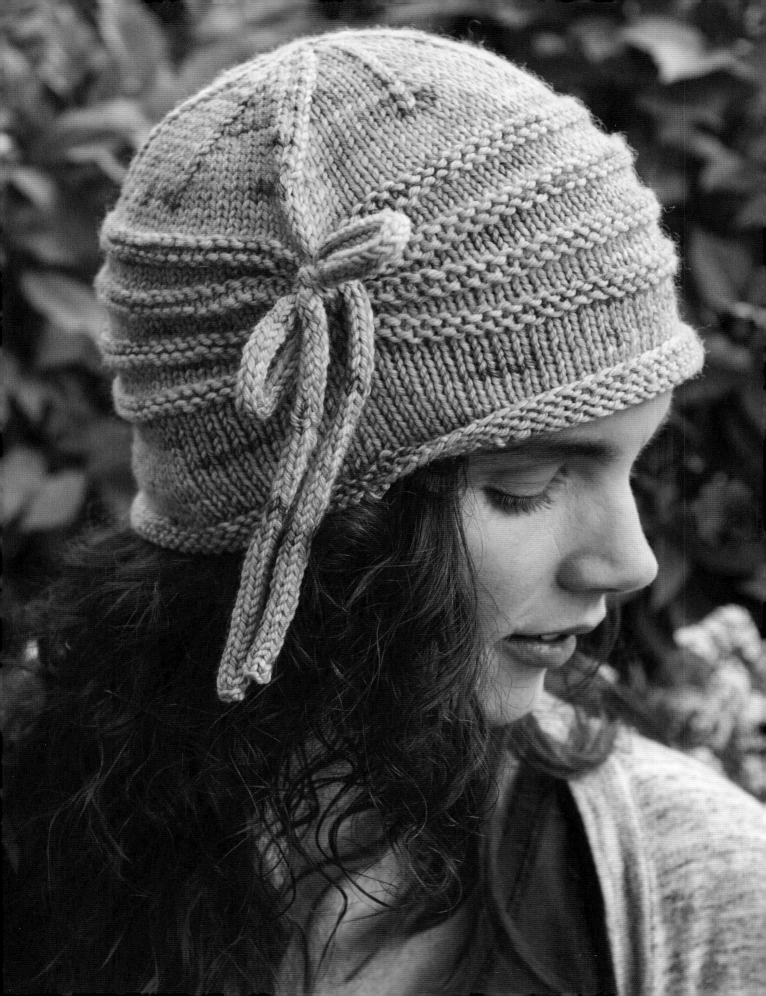

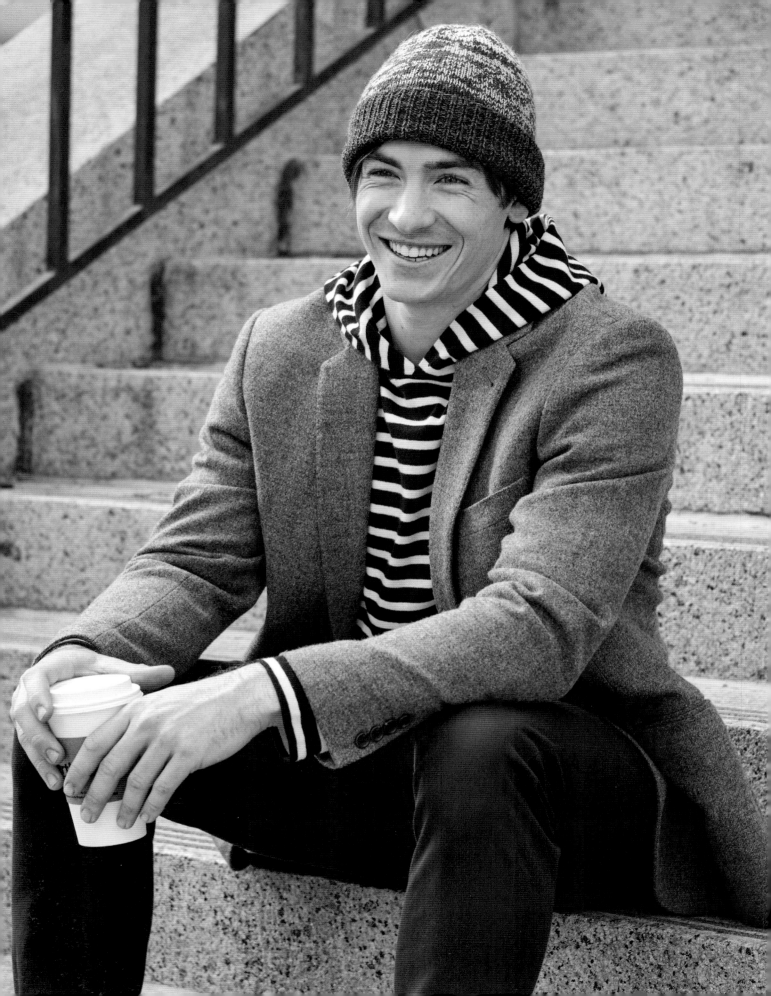

DUALITY WATCH CAP

Designed by *Alexis Winslow*

You get more than you might expect with this versatile slouchy hat. It's knit with two yarns held together for a marled effect and an extra-warm fabric. The main color stays the same, and the second color is changed to go from darker to lighter to create a gradient. Wear it with the brim folded up, watch-cap style, or down, as a toque.

FINISHED SIZE

About 15 (17, 19)" (38 [43, 48.5] cm) circumference at brim, unstretched, and 11½ (11½, 11¾)" (29 [29, 30] cm) tall with brim not folded.

To fit 18 (20¼, 22½)" (45.5 [51.5, 57] cm) head circumference.

Hat shown in 15" (38 cm) size.

YARN

Fingering weight (#1 Superfine).

Shown here: Berroco Ultra Alpaca Fine (50% Peruvian wool, 30% nylon, 20% superfine alpaca; 433 yd [396 m]/100 g): #1234 cardinal (MC), #1207 salt & pepper (CC1), #1209 moonshadow (CC2), and #1201 winter white (CC3), 1 skein each.

NEEDLES

Brim
Size U.S. 5 (3.75 mm): 16" (40.5 cm) circular (cir) or set of 4 or 5 double-pointed (dpn).

Body
Size U.S. 6 (4 mm): 16" (40.5 cm) cir or set of 4 or 5 dpn.

Adjust needle sizes if necessary to obtain the correct gauge.

NOTIONS

Markers (m); tapestry needle.

GAUGES

27½ sts and 32 rnds = 4" (10 cm) in K1, P1 Rib on smaller needles with 2 strands of yarn.

23 sts and 33 rnds = 4" (10 cm) in St st on larger needles with 2 strands of yarn.

NOTES

This slouchy folded brim beanie is worked with two strands of yarn held together for a marled effect, while at the same time the background color is gradually changed to create a gradient effect.

The hat is worked in the round from the bottom up.

STITCH GUIDE

K1, P1 Rib in rounds: (even number of sts)

All rnds: *K1, p1; rep from * to end.

BRIM

With smaller needles and 1 strand each of MC and CC1 held together, use the long-tail method (see Glossary) to CO 104 (116, 130) sts. Place marker (pm) for beg of rnd and join for working in rnds, being careful not to twist sts. Work in K1, P1 Rib (see Stitch Guide) until piece meas 3" (7.5 cm) from CO edge.

BODY

Change to larger needles. Work even in St st (knit every rnd) until piece meas 5¼" (13.5 cm) from CO edge.
Cut CC1 and join CC2 instead. With 1 strand each of MC and CC2, work even in St st until piece meas 8½" (21.5 cm) from CO edge.
Cut CC2 and join CC3 instead. With 1 strand each of MC and CC3, work even in St st until piece meas 9¼" (23.5 cm) from CO edge.

CROWN

Set-up rnd: [K13, pm] 7 (8, 9) times, knit to end.
Next rnd: (dec) *Knit to 2 sts before m, k2tog; rep from * to last 2 sts, k2tog—8 (9, 10) sts dec'd.
Rep dec rnd every other rnd 9 (9, 10) more times—24 (26, 20) sts rem.
Cut yarn, leaving an 8" (20.5 cm) tail. Thread tail on a tapestry needle, draw through rem sts, pull tight to close hole, and fasten off on WS.

FINISHING

Weave in loose ends and block hat to measurements.

" A Designer's Yarn

One of my first entrepreneurial enterprises was making knitted hats in college. I started out knitting them by hand, but eventually graduated to using a knitting machine. I could make a hat in an hour and sold dozens of them. They all looked the same, with colorful thick stripes and a pom-pom on top. I took custom orders and let people pick the colors of their stripes. I used super-saver yarn, and lined the brim with soft polar fleece—a tricky tactic to keep the cheap yarn from itching that I sold as a mark of handmade quality.

—Alexis

"

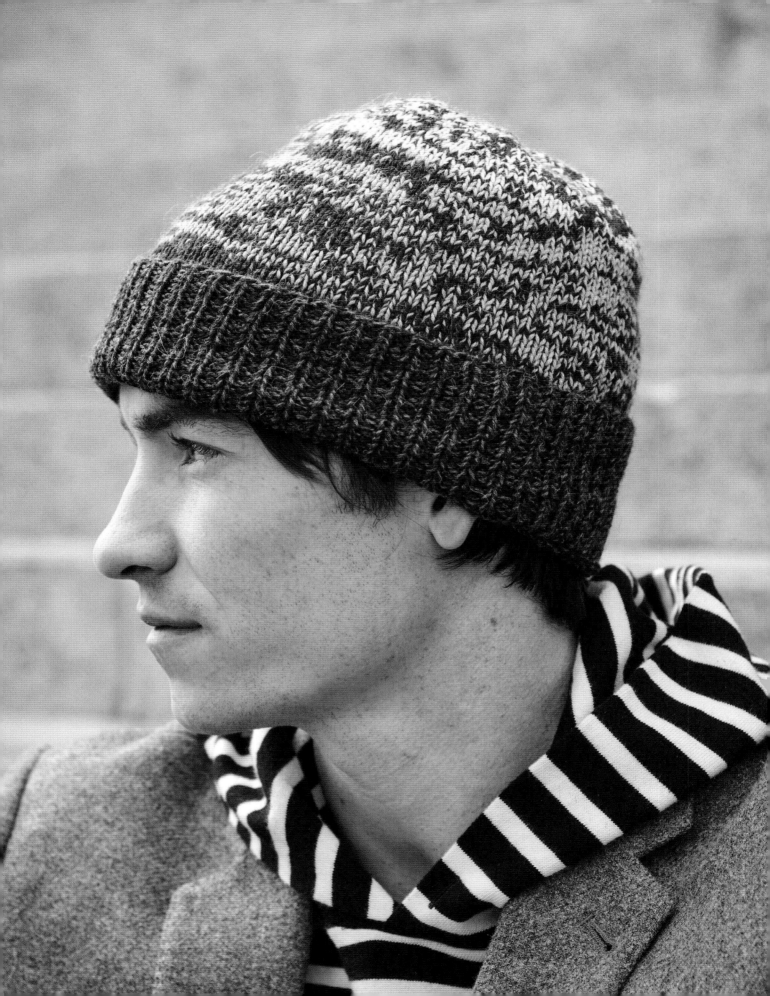

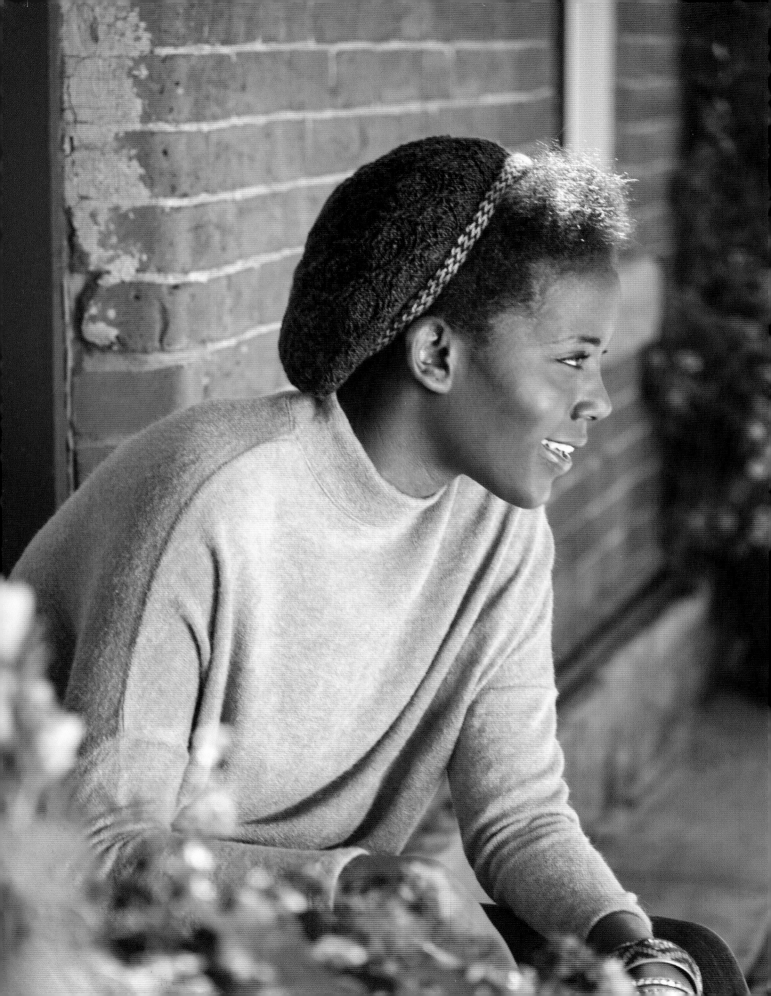

THISTLE LACE BERET

Designed by *Courtney Spainhower*

Berets are versatile, timeless classics and satisfying knits. This updated style features a graphic band and an engaging lace pattern knitters of all experience levels will enjoy. You need just a bit of contrasting color for the Latvian braid band, so one skein of each yarn is enough to make both color combinations!

FINISHED SIZE

About 18" (45.5 cm) circumference at brim, unstretched, and 8" (20.5 cm) tall; 10½" (26.5 cm) diameter for beret shaping.

To fit 19–22" (48.5–56 cm) head circumference.

YARN

Sportweight (#2 Fine).

Shown here: Baah Yarns Aspen (75% merino wool, 15% silk, 10% cashmere; 330 yd [302 m]/100 g): navy and sage, 1 skein each.

Purple version uses navy as MC and sage as CC; light green version uses sage as MC and navy as CC.

NEEDLES

Size U.S. 5 (3.75 mm): 16" (40.5 cm) circular (cir) and set of 4 or 5 double-pointed (dpn).

Adjust needle size if necessary to obtain the correct gauge.

NOTIONS

Markers (m); tapestry needle.

GAUGES

26½ sts and 32 rnds = 4" (10 cm) in Latvian Braid patt.

20 sts and 29 rnds = 3½" (9 cm) wide and 3" (7.5 cm) tall in Thistle Lace patt.

STITCH GUIDE

Sk2p: Slip 1 knitwise, k2tog, pass slipped st over decreased st—2 sts dec'd.

Sk2p at marker: Slip 1 knitwise, temporarily slip the last stitch of the round to the right needle, remove the marker, return the slipped stitch to the left needle, k2tog, pass slipped st over decreased st, and replace the marker on the right needle.

Latvian Braid Pattern: (even number of sts)

Note: Strands are deliberately twisted on Rnd 1 and untwisted on Rnd 2.

Set-up rnd: *K1 with MC, K1 with CC; rep from * to end.

Rnd 1: Starting with both colors in front of work, *p1 with MC, bring CC over MC, p1 with CC, bring MC over CC; rep from * to end.

Rnd 2: Starting with both colors in front of work, *p1 with MC, bring CC under MC, p1 with CC, bring MC under CC; rep from * to end.

Rep Rnds 1 and 2 for patt.

Thistle Lace Pattern: (multiple of 10 sts + 10)

Note: The beginning of the round shifts in Rnds 7, 9, 11, 23, 25, 27, and 29.

Rnd 1: *[K1, yo] 3 times, k2tog, sk2p, ssk, yo; rep from * to end.

Rnd 2 and all even-numbered rnds: Knit.

Rnd 3: *K1, [k1, yo] 2 times, k3, sk2p, k1; rep from * to end.

Rnd 5: *K2, yo, k3, yo, k2, sk2p; rep from * to end.

Rnd 7: K2, yo, k5, yo, k1, *sk2p, k1, yo, k5, yo, k1; rep from * to last 2 sts, sk2p at marker (see above).

Rnd 9: [K1, yo] 2 times, ssk, k1, k2tog, yo, k1, *yo, sk2p, yo, k1, yo, ssk, k1, k2tog, yo, k1; rep from * to last 2 sts, yo, sk2p at marker.

Rnd 11: K1, yo, k2, yo, sk2p, yo, k1, *[k1, yo, sk2p, yo, k1] 2 times; rep from * to last 3 sts, k1, yo, sk2p at marker.

Rnd 13: *Yo, k3, sk2p, k3, yo, k1; rep from * to end.

Rnd 15: *Yo, k1, yo, k2tog, sk2p, ssk, [yo, k1] 2 times; rep from * to end.

Rnd 17: *Yo, k3, sk2p, k3, yo, k1; rep from * to end.

Rnd 19: *K1, yo, k2, sk2p, k2, yo, k2; rep from * to end.

Rnd 21: *K2, yo, k1, sk2p, k1, yo, k3; rep from * to end.

Rnd 23: K1, yo, k2, yo, sk2p, yo, k2, yo, *[sk2p, yo, k2, yo] 2 times; rep from * to last 2 sts, sk2p at marker.

Rnd 25: K4, yo, k1, yo, k2, *k1, sk2p, k3, yo, k1, yo, k2; rep from * to last 3 sts, k1, sk2p at marker.

Rnd 27: K1, ssk, [yo, k1] 3 times, *yo, k2tog, sk2p, ssk, [yo, k1] 3 times; rep from * to last 4 sts, yo, k2tog, sk2p at marker.

Rnd 29: K4, yo, k1, yo, *k3, sk2p, k3, yo, k1, yo; rep from * to last 5 sts, k3, sk2p at marker.

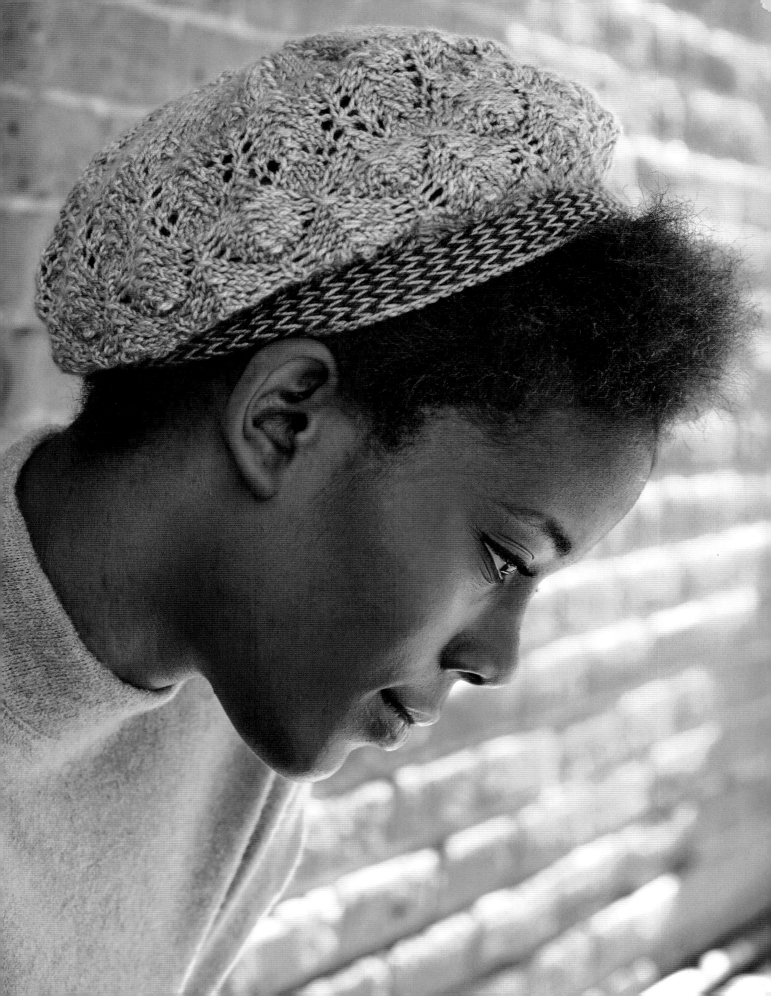

BAND

With MC and cir needle, CO 120 sts, place marker (pm) for beg of rnd and join for working in rnds, being careful not to twist sts. Work even in St st (knit every rnd) for 2 rnds. Work Latvian Braid patt (see Stitch Guide) including Set-up Rnd once, then work Rnds 1 and 2 of Latvian Braid patt 3 more times. Cut CC.

BODY

The rest of the hat is knit with MC only.
Knit 1 rnd.
Next rnd: (inc) K2, k1f&b (see Glossary), [k5, k1f&b] 19 times, k3—140 sts.
Work Rnds 1–29 of Thistle Lace patt from Stitch Guide or chart once, then knit 1 rnd.
Work Rnds 5–25 of Thistle Lace patt once, then knit 1 rnd.

CROWN

Work crown decreases as follows, changing to dpn when there are too few sts to work comfortably on cir needle.
Rnd 1: *K3, yo, sk2p, yo, k4; rep from * to end—140 sts.
Rnd 2 and all even-numbered rnds: Knit.
Rnd 3: *K3, sk2p, k4; rep from * to end—112 sts.
Rnd 5: *K2, yo, sk2p, yo, k3; rep from * to end—112 sts.
Rnd 7: *K2, sk2p, k3; rep from * to end—84 sts.
Rnd 9: *K1, yo, sk2p, yo, k2; rep from * to end—84 sts.
Rnd 11: *K1, sk2p, k2; rep from * to end—56 sts.
Rnd 13: *Yo, sk2p, yo; rep from * to last 2 sts, k2—56 sts.
Rnd 15: *Sk2p, k1; rep from * to end—28 sts.
Rnd 17: *Ssk; rep from * to end—14 sts.
Cut yarn. Thread tail on a tapestry needle, draw through rem sts, pull tight to close hole, and fasten off on WS.

FINISHING

Using tapestry needle, weave in all ends neatly. Gently wet-block (see Glossary).

Hat Trick

When adding just a hint of color to a hat, you can end up with a lot of scrap yarn. So, you can either raid your scrap bin to add this colorwork, or have enough yarn left over to knit the hat in the opposite color order!

—Courtney

Thistle Lace

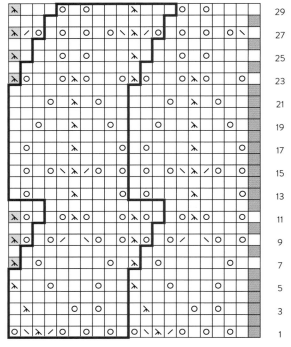

10-st repeat

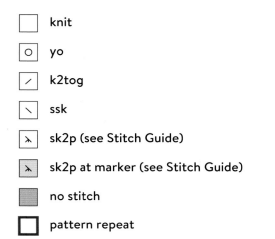

knit

yo

k2tog

ssk

sk2p (see Stitch Guide)

sk2p at marker (see Stitch Guide)

no stitch

pattern repeat

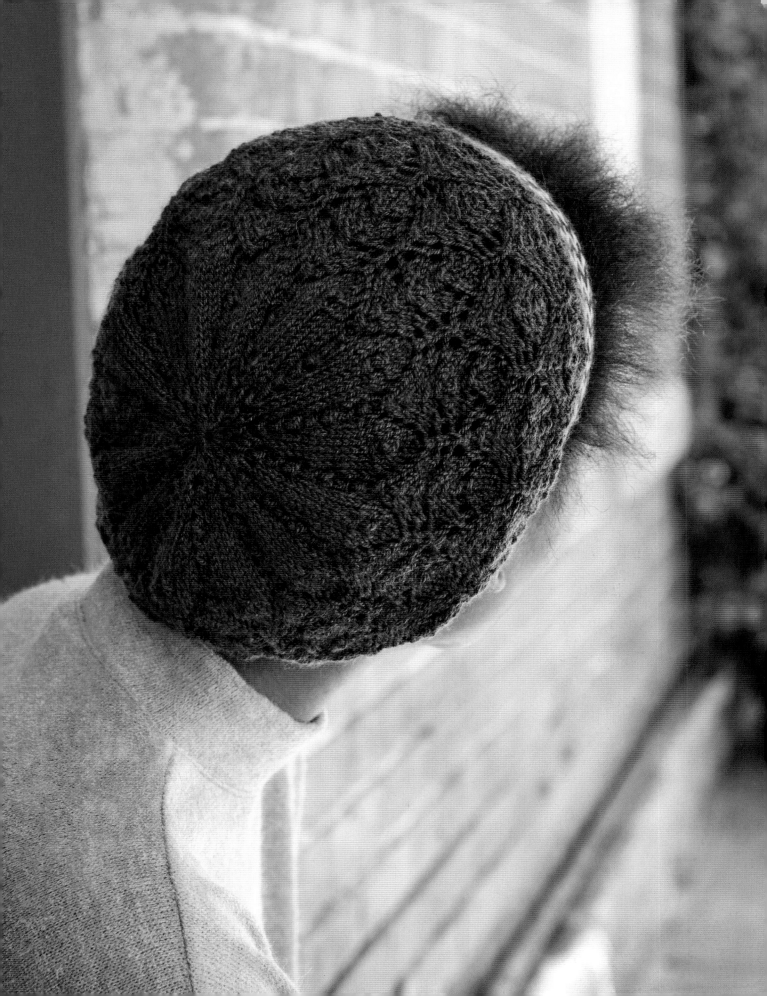

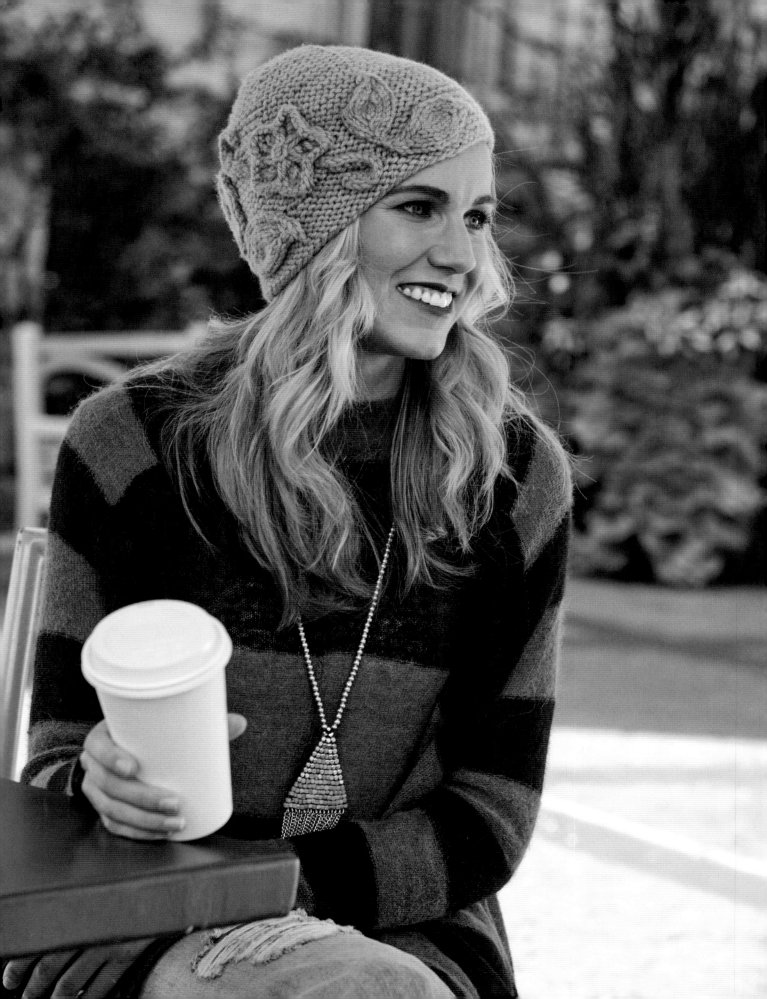

BLOSSOM APPLIQUÉD BEANIE

Designed by *Alexis Winslow*

Knitted flower and leaf embellishments adorn an otherwise simple garter-stitch hat. The hat is knit flat and seamed, and the appliqués are knit separately. Use one or more contrasting colors for the foliage for an eye-catching variation.

FINISHED SIZE

About 21½ (23, 24½)" (54.5 [58.5, 62] cm) circumference at brim and 7¾ (8, 8¼)" (19.5 [20.5, 21] cm) tall.

To fit 21½–22½ (23–24, 24½–25½)" (54.5–57 [58.5–61, 62–65] cm) head circumference.

Hat shown in 23" (58.5 cm) size.

YARN

Chunky weight (#5 Bulky).

Shown here: The Plucky Knitter Plucky Bulky (100% merino wool; 135 yd [123 m]/4 oz [115 g]); Lake Placid, 2 skeins.

NEEDLES

Size U.S. 10 (6 mm): straight.

Adjust needle size if necessary to obtain the correct gauge.

NOTIONS

Markers (m); tapestry needle; sewing pins.

GAUGE

13 sts and 32 rows = 4" (10 cm) in garter st.

NOTES

The hat is knitted flat on straight needles. The embellishments are worked separately then sewn to the hat at the end.

BODY

Using the long-tail method (see Glossary), CO 72 (77, 82) sts.

Work even in garter st (knit every row) until piece meas 4¾" (12 cm) from CO edge, ending after a RS row.

Set-up row: (WS) K2, *place marker (pm), k14 (15, 16); rep from * to end.

Row 1: (dec—RS) *Knit to 2 sts before m, k2tog, slip marker (sl m); rep from * to last m, k2—5 sts dec'd.

Row 2: Knit.

Rep the last 2 rows 10 (11, 12) more times, removing markers as you come to them on the last row—17 sts.

Next row: (RS) K1, *k2tog; rep from * to end—9 sts.

Cut yarn, leaving an 8" (20.5 cm) tail. Thread tail on a tapestry needle, draw through rem sts, pull tight to close hole, and fasten off on WS.

KNITTED EMBELLISHMENTS

Small (Large) Pair of Leaves

Make one pair of leaves in small size and another pair in large size.

CO 1 st, leaving a 12" (30.5 cm) tail to later sew leaf to hat.

***Row 1:** (RS) K1f&b—2 sts.

Row 2: (WS) P1, pm, M1P (see Glossary), p1—3 sts.

Row 3: Knit to m, sl m, M1 (see Glossary), knit to end—1 st inc'd.

Row 4: Purl to m, sl m, M1P, purl to end—1 st inc'd.

Rep the last 2 rows until you have 8 (10) sts.

Work 2 rows even in St st (knit on RS, purl on WS).

Next row: (WS) Purl to m, sl m, ssp (see Glossary), purl to end—1 st dec'd.

Next row: (RS) Knit to m, sl m, k2tog, knit to end—1 st dec'd.

Rep the last 2 rows until 2 sts rem, removing the marker on the last row.

Next row: P2tog.

With 1 st on needle, rep from * for the second leaf. Cut yarn, leaving a 12" (30.5 cm) tail, and draw tail through last st to BO.

Flower (make one)

CO 41 sts, leaving a 12" (30.5 cm) tail to later sew flower to hat.

Row 1: (RS) K4, *sl 1, k7; rep from * to last 5 sts, sl 1, k4.

Row 2: (WS) P2tog, *p5, p3tog; rep from * to last 7 sts, p5, p2tog—31 sts.

Row 3: K3, *sl 1, k5; rep from * to last 4 sts, sl 1, k3.

Row 4: P2tog, *P1, sl 1, p1, p3tog; rep from * to last 5 sts, p1, sl 1, p1, p2tog—21 sts.

Row 5: K2, *sl 1, k3; rep from * to last 3 sts, sl 1, k2.

Row 6: P2tog, *sl 1, p3tog; rep from * to last 3 sts, sl 1, p2tog—11 sts.

Row 7: (BO) K2tog, *k2tog, pass rightmost st on right needle over leftmost st and off the needle as in regular BO; rep from * to last st, k1, pass rightmost st on right needle over leftmost st and off the needle.

Cut yarn, leaving a 12" (30.5 cm) tail, and draw tail through last st to BO. Use BO tail to seam selvedges of flower and close flower.

Stem (make 2)

Using the long-tail method, CO 15 sts, leaving a 12" (30.5 cm) tail to later sew stem to hat.

BO loosely and very neatly.

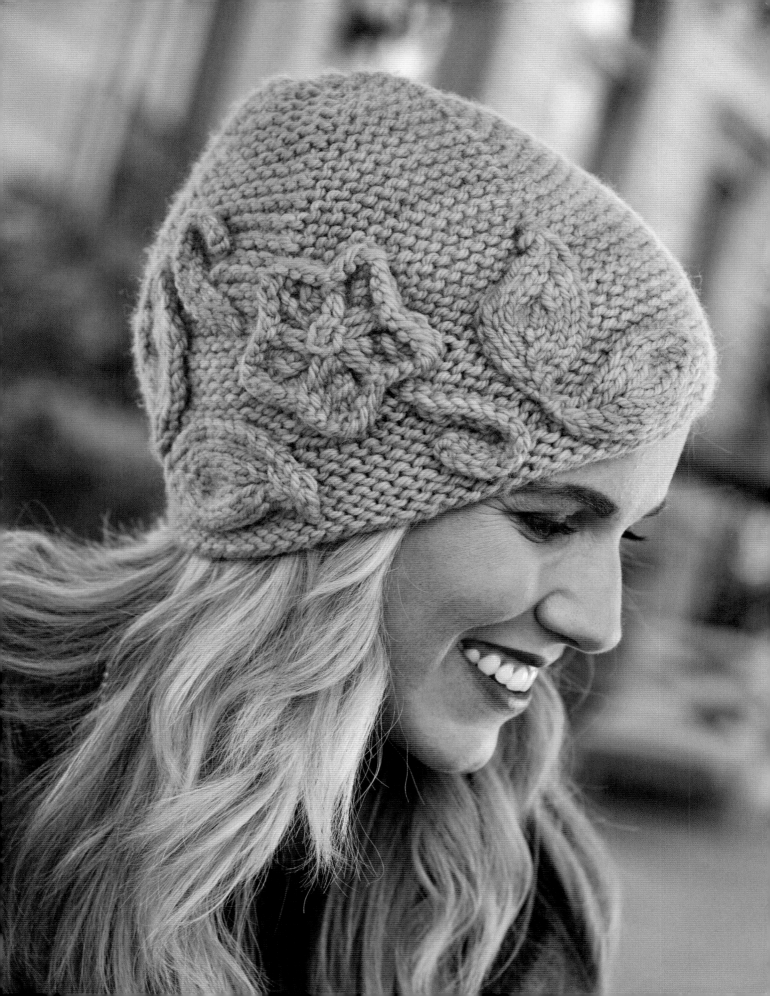

FINISHING

Sew back seams of hat together using the mattress stitch (see Glossary). Fold the hat in half with the back seam on the left. Using sewing pins, arrange the leaves, stems, and flower on the hat in an attractive way (see photos or templates, below). Try the hat on and reposition embellishments if necessary.

Use tail from cast-on and tapestry needle to sew each embellishment to the hat, using a running stitch (see Glossary) with small neat stitches and being very careful not to pull too tightly to maintain elasticity in the hat. *Note: Maintain dimensionality in the embellishments by sewing 1 st away from edge and stitching loosely.* Weave in loose ends. Block hat once embellishments are attached.

APPLIQUÉ TEMPLATES

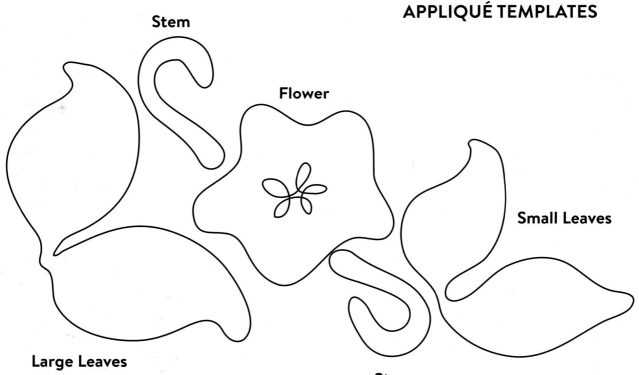

Stem

Flower

Small Leaves

Large Leaves

Stem

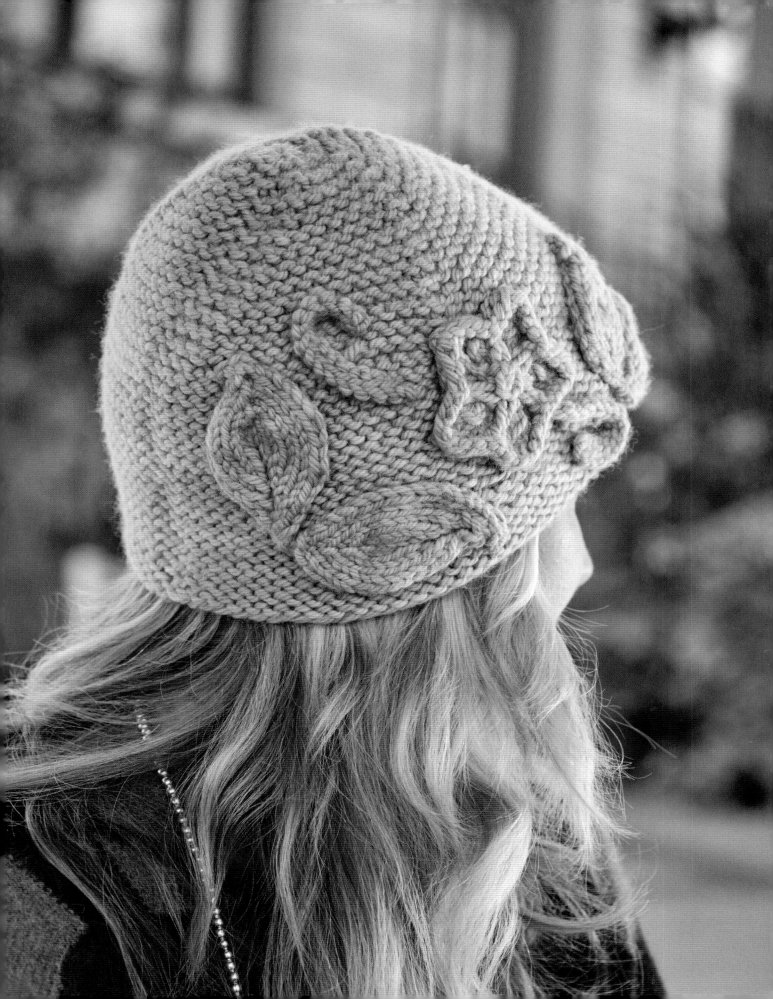

Abbreviations

Beg	Begin/beginning		**P**	Purl
Cir	Circular		**Patt**	Pattern
Cm	Centimeter(s)		**Pm**	Place marker
Cn	Cable needle		**P2tog**	Purl two stitches together; one stitch decreased (see Glossary)
CO	Cast on			
Cont	Continue		**Pwise**	Purlwise
Dec(s)('d)	Decrease(s)(d)		**Rem**	Remain(ing)
Dpn	Double-pointed needle(s)		**Rep**	Repeat(s)
			Rnd(s)	Round(s)
Est	Establish(ed)		**RS**	Right side
Foll	Follow(ing)		**Sl**	Slip
Inc(s)('d)	Increase(s)(d)		**Ssk**	Slip, slip, knit slipped stitches together; one stitch decreased (see Glossary)
K	Knit			
K2tog	Knit two stitches together; one stitch decreased (see Glossary)			
			St(s)	Stitch(es)
K1f&b	Knit into the front and back of stitch; one stitch increased (see Glossary)		**St st**	Stockinette stitch
			Tbl	Through back loop
			WS	Wrong side
Kwise	Knitwise		**Wyb**	With yarn in back
M	Marker		**Wyf**	With yarn in front
M1	Make one stitch; right or left slanting increase as indicated by R/L (see Glossary)		**Yo**	Yarnover
			[]	Repeat instructions within brackets as written
Meas	Measure(s)		**()**	Alternate instructions within parentheses

Glossary

Bind-Off

Standard Bind-Off

Knit the first stitch, *knit the next stitch (two stitches on right needle), insert left needle tip into first stitch on right needle **(Figure 1)** and lift this stitch up and over the second stitch **(Figure 2)** and off the needle **(Figure 3)**. Repeat from * for the desired number of stitches.

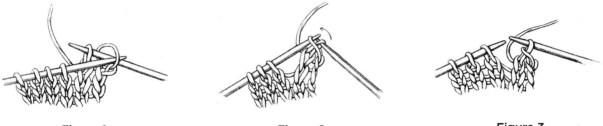

| Figure 1 | Figure 2 | Figure 3 |

Blocking

Steam Blocking

Pin the pieces to be blocked to a blocking surface. Hold an iron set on the steam setting ½" (1.3 cm) above the knitted surface and direct the steam over the entire surface (except ribbing). You can get similar results by lapping wet cheesecloth on top of the knitted surface and touching it lightly with a dry iron. Lift and set down the iron gently; do not use a pushing motion.

Wet-Blocking

Soak in lukewarm water until saturated. Gently squeeze out much of the water (do not wring) and lay flat on a clean, dry towel or mesh drying rack; shape to measurements and leave until completely dry.

Cables

Slip the designated number of stitches (usually two or three) onto a cable needle, hold the cable needle in front of the work for a left-leaning twist **(Figure 1)** or in back of the work for a right-leaning twist **(Figure 2)**, work the specified number of stitches from the left needle (usually the same number of stitches that were placed on the cable needle), then work the stitches from the cable needle in the order in which they were placed on the needle **(Figure 3)**.

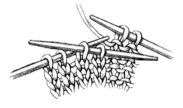

Figure 1

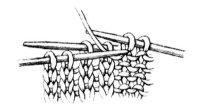

Figure 2

Figure 3

Cast-Ons

Backward-Loop Cast-On

*Loop working yarn and place it on needle backward so that it doesn't unwind. Repeat from *.

Cable Cast-On

If there are no stitches on the needles, make a slipknot of working yarn and place it on the left needle, then use the knitted method to cast on one more stitch—two stitches on needle. When there are at least two stitches on the left needle, hold needle with working yarn in your left hand. *Insert right needle between the first two stitches on left needle **(Figure 1)**, wrap yarn around needle as if to knit, draw yarn through **(Figure 2)**, and place new loop on left needle **(Figure 3)** to form a new stitch. Repeat from * for the desired number of stitches, always working between the first two stitches on the left needle.

Figure 1

Figure 2

Figure 3

Emily Ocker's Circular Beginning

Make a simple loop of yarn with the short end hanging down. With a double-pointed needle, *draw a loop through main loop, then draw another loop through this loop. Repeat from * for each stitch to be cast on. After several inches have been worked, pull on the short end to tighten the loop and close the circle.

Knitted Cast-On

If there are no stitches on the needles, make a slipknot of working yarn and place it on the left needle. When there is at least one stitch on the left needle, *use the right needle to knit the first stitch (or slipknot) on left needle **(Figure 1)** and place new loop onto left needle to form a new stitch **(Figure 2)**. Repeat from * for the desired number of stitches, always working into the last stitch made.

Figure 1 Figure 2

Long-Tail (Continental) Cast-On

Leaving a long tail (about ½" [1.3 cm] for each stitch to be cast on), make a slipknot and place on right needle. Place thumb and index finger of your left hand between the yarn ends so that working yarn is around your index finger and tail end is around your thumb and secure the yarn ends with your other fingers. Hold your palm upward, making a V of yarn **(Figure 1)**. *Bring needle up through loop on thumb **(Figure 2)**, catch first strand around index finger, and go back down through loop on thumb **(Figure 3)**. Drop loop off thumb and, placing thumb back in V configuration, tighten resulting stitch on needle **(Figure 4)**. Repeat from * for the desired number of stitches.

Figure 1 Figure 2

Figure 3 Figure 4

Provisional (Crochet Chain) Cast-On

With smooth, contrasting waste yarn and crochet hook, make a loose chain of about four stitches more than you need to cast on. Cut yarn and pull tail through last chain to secure. With needle, working yarn, and beginning two stitches from last chain worked, pick up and knit one stitch through the back loop of each chain **(Figure 1)** for desired number of stitches. Work the piece as desired, and when you're ready to use the cast-on stitches, pull out the crochet chain to expose the live stitches **(Figure 2)**.

Figure 1 Figure 2

Decreases

Knit 2 Together (k2tog)

Knit two stitches together as if they were a single stitch.

Knit 3 Together (k3tog)

Knit 3 stitches together as if they were a single stitch.

Purl 2 Together (p2tog)

Purl two stitches together as if they were a single stitch.

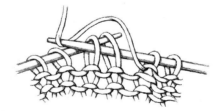

Purl 3 Together (p3tog)

Purl 3 stitches together as if they were a single stitch.

Slip, Slip, Knit (ssk)

Slip two stitches individually knitwise **(Figure 1)**, insert left needle tip into the front of these two slipped stitches, and use the right needle to knit them together through their back loops **(Figure 2)**.

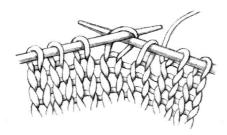

Figure 1

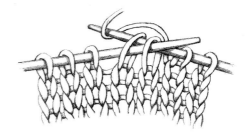

Figure 2

Slip, Slip, Purl (ssp)

Holding yarn in front, slip two stitches individually knitwise **(Figure 1)**, then slip these two stitches back onto left needle (they will be turned on the needle) and purl them together through their back loops **(Figure 2)**.

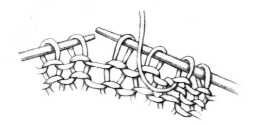

Figure 1

Figure 2

Gauge

Measuring Gauge

Knit a swatch at least 4" (10 cm) square. Remove the stitches from the needles or bind them off loosely and lay the swatch on a flat surface. Place a ruler over the swatch and count the number of stitches across and number of rows down (including fractions of stitches and rows) in 4" (10 cm) and divide this number by four to get the number of stitches (including fractions of stitches) in 1" (2.5 cm). Repeat two or three times on different areas of the swatch to confirm the measurements. If you have more stitches and rows than called for in the instructions, knit another swatch with larger needles; if you have fewer stitches and rows, knit with smaller needles.

I-Cord (also called Knit-Cord)

With double-pointed needle, cast on desired number of stitches. *Without turning the needle, slide the stitches to other end of the needle, pull the yarn around the back, and knit the stitches as usual; repeat from * for desired length.

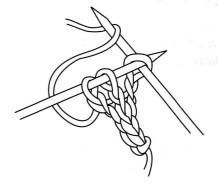

Increases

K1f&b (Bar Increase)

Knit into a stitch but leave the stitch on the left needle **(Figure 1)**, then knit through the back loop of the same stitch **(Figure 2)** and slip the original stitch off the needle **(Figure 3)**.

Figure 1

Figure 2

Figure 3

P1f&b (Bar Increase)

Purl into a stitch but leave the stitch on the left needle **(Figure 1)**, then purl through the back loop of the same stitch **(Figure 2)** and slip the original stitch off the needle.

Figure 1

Figure 2

Make-One (M1) Increases

Note: Use the left slant increase if no direction of slant is specified.

Left Slant (M1L) and Standard M1
With left needle tip, lift strand between needles from front to back **(Figure 1)**. Knit lifted loop through the back **(Figure 2)**.

Figure 1 Figure 2

Right Slant (M1R)
With left needle tip, lift strand between needles from back to front **(Figure 1)**. Knit lifted loop through the front **(Figure 2)**.

Figure 1 Figure 2

Purl (M1P)
For purl versions, work as above, purling lifted loop.

Figure 1

Figure 2

Joining for Working in Rounds

For projects that begin with ribbing or stockinette st, simply arrange the stitches for working in rounds, then knit the first stitch that was cast on to form a tube.

For projects that begin with seed, garter, or reverse stockinette st, arrange the needle so that the yarn tail is at the left needle tip. Holding the yarn in back, slip the first st from the right needle onto the left needle **(Figure 1)**, bring the yarn to the front between the two needles, and slip the first two stitches from the left tip to the right tip **(Figure 2)**, then bring the yarn to the back between the two needles and slip the first stitch from the right tip to the left tip **(Figure 3)**.

Figure 1

Figure 2

Figure 3

Pick Up and Knit

Along CO or BO Edge

With right side facing and working from right to left, insert the tip of the needle into the center of the stitch below the bind-off or cast-on edge **(Figure 1)**, wrap yarn around needle, and pull through a loop **(Figure 2)**. Pick up one stitch for every existing stitch.

Figure 1

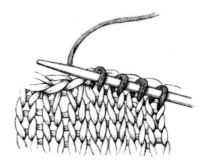

Figure 2

Along Side Edge

With right side facing and working from right to left, insert tip of needle between last and second-to-last stitches, wrap yarn around needle, and pull through a loop. Pick up and knit about three stitches for every four rows, adjusting as necessary so that picked-up edge lies flat.

Pom-Poms

Cut two circles of cardboard, each ½" (1.3 cm) larger than desired finished pom-pom width. Cut a small circle out of the center and a small edge out of the side of each circle **(Figure 1)**. Tie a strand of yarn between the circles, hold circles together and wrap with yarn—the more wraps, the thicker the pom-pom. Knot the tie strand tightly and cut between the circles **(Figure 2)**. Place pom-pom between two smaller cardboard circles held together with a needle and trim the edges **(Figure 3)**.

Figure 1

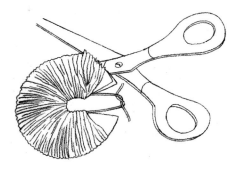

Figure 2

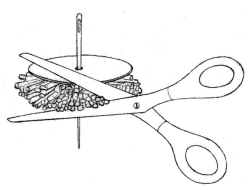

Figure 3

Seaming

Backstitch

Working from right to left, one stitch in from selvedge, bring threaded needle up through both pieces of knitted fabric **(Figure 1)**, then back down through both layers a short distance (about a row) to the right of the starting point **(Figure 2)**. *Bring needle up through both layers a row-length to the left of backstitch just made **(Figure 3)**, then back down to the right, in same hole used before **(Figure 4)**. Repeat from *, working backward one row for every two rows worked forward.

Figure 1

Figure 2

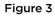

Figure 3

Figure 4

Mattress Stitch

Place the pieces to be seamed on a table, right sides facing up. Begin at the lower edge and work upward as follows: Insert threaded needle under one bar between the two edge stitches on one piece, then under the corresponding bar plus the bar above it on the other piece **(Figure 1)**. *Pick up the next two bars on the first piece **(Figure 2)**, then the next two bars on the other **(Figure 3)**. Repeat from *, ending by picking up the last bar or pair of bars on the first piece.

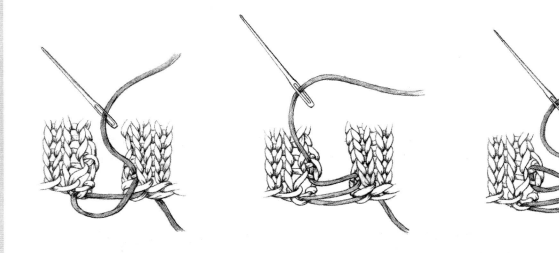

| Figure 1 | Figure 2 | Figure 3 |

Running Stitch

Working small straight stitches, pass the threaded needle over one knitted stitch and under the next to form a dashed line. The stitches can be worked in equal or varying lengths, horizontally, vertically, or diagonally.

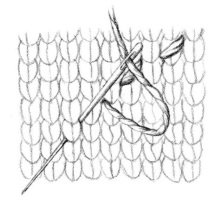

Whipstitch

With right sides (RS) of work facing and working through edge stitches, bring threaded needle out from back to front, along edge of piece.

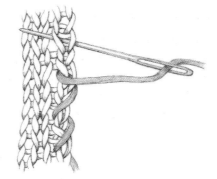

Weave in Loose Ends

Thread the ends on a tapestry needle and trace the path of a row of stitches **(Figure 1)** or work on the diagonal, catching the back side of the stitches **(Figure 2)**. To reduce bulk, do not weave two ends in the same area. To keep color changes sharp, work the ends into areas of the same color.

| Figure 1 | Figure 2 |

Yarnover (Yo)

Yarnover between Two Knit Stitches

Wrap the working yarn around the needle from front to back and in position to knit the next stitch.

About the Designers

Meghan Babin

Meghan is the editor of *Interweave Knits*. She recently relocated to Colorado from New York state and still gets a thrill when tumbleweeds roll across the highway on a windy day. Her designs have been featured in *Interweave Knits, knit.purl, knit.wear, Twist Collective,* and *Knitty.*

Website: knittingdaily.com

Ravelry Designer's Page: ravelry.com/designers/meghan-babin

Rachel Coopey

Rachel was taught to knit by her grandmother and mother when she was little, and she still has the extremely long garter-stitch scarf to prove it. She has published three books of sock and accessory designs and can be found wearing and knitting hats all year round.

Website: coopknits.co.uk

Ravelry Designer's Page: ravelry.com/designers/rachel-coopey

Faina Goberstein

Faina Goberstein is a prolific knitwear designer, author, and inspiring teacher. She is the coauthor of *The Art of Seamless Knitting* and *The Art of Slip-Stitch Knitting,* both from Interweave. Faina is best known for her elegant and well-fitted classic designs that show off textures such as cables, brioche, lace, and slip-stitch patterns.

Website: fainasknittingmode.com

Ravelry Designer's Page: ravelry.com/designers/faina-goberstein

Tanis Gray

A graduate of RISD, Tanis Gray lives in Fairfax, Virginia, with her husband and son. She has worked at Martha Stewart, HBO, Focus Features, in the art department in the film and television industries, and as the yarn editor at *Vogue Knitting* and coeditor of *Knit.1.* Tanis is currently working on her eighth knitting book, photographing knitting books for others, and sewing project bags for her Etsy shop.

Website: tanisknits.com

Ravelry Designer's Page: ravelry.com/designers/tanis-gray

Melissa LaBarre

Melissa LaBarre is a freelance knitwear designer and coauthor of the books *Weekend Hats, New England Knits,* and *Weekend Wraps,* all from Interweave. Her designs have been published in *Knitscene, Vogue Knitting,* and *Twist Collective,* as well as in design collections for Quince & Co., Classic Elite, and Brooklyn Tweed, among many others. She lives in Massachusetts with her husband and daughters.

Website: knittingschooldropout.com
Ravelry Designer's Page: ravelry.com/designers/melissa-labarre

Annie Rowden

Annie Rowden is originally from England but lives in Northern California. She is a dairy farmer obsessed with fiber, knitting, and natural dyes. She focuses on designing with yarns that are from domestic fiber, naturally dyed, or organic and loves to support the companies and farmers providing these wonderful wools.

Website: byannieclaire.com

Ravelry Designer's Page: ravelry.com/designers/annie-rowden

Courtney Spainhower

Courtney Spainhower is a stay-at-home mom, knitting instructor, and the lady behind Pink Brutus Knits. She is the author of *Family-Friendly Knits* (Interweave). She has been designing full-time since 2009.

Website: pinkbrutus.com

Ravelry Designer's Page: ravelry.com/designers/courtney-spainhower

Melissa Thomson

Melissa Thomson is a Canadian yarn dyer and knitwear designer and the founder of Sweet Fiber Yarns. She strives to create stunning colorways and intuitive designs that are reflective of the lush landscapes and waters of western Canada. Melissa lives in beautiful British Columbia and can't imagine a more knit-friendly place to call home.

Website: sweetfiberyarns.com

Ravelry Designer's Page: ravelry.com/designers/melissa-thomson

Robin Ulrich

Robin Ulrich knits and designs from her home in Ohio, where she also blogs about knitting, nature, and other pursuits.

Website: robinulrich.blogspot.com

Ravelry Designer's Page: ravelry.com/designers/robin-ulrich

Alexis Winslow

Alexis Winslow is a knitwear and textile designer living in Brooklyn, New York. Her designs have a bold, graphic aesthetic and often utilize interesting color or construction techniques. Alexis is the author of *Graphic Knits* (Interweave).

Website: knitdarling.com

Ravelry Designer's Page: ravelry.com/designers/alexis-winslow

Heather Zoppetti

Heather Zoppetti is a knitwear designer and instructor. Her patterns have been published in many Interweave publications, such as *Interweave Knits, Knitscene,* and *Jane Austen Knits,* in *Vogue Knitting* and *Creative Knitting,* and by yarn companies such as Manos del Uruguay, Baah Yarns, and The Alpaca Yarn Company. Heather is the owner and founder of Stitch Sprouts and the author of *Everyday Lace* and *Unexpected Cables,* both from Interweave.

Website: hzoppettidesigns.com

Ravelry Designer's Page: ravelry.com/designers/heather-zoppetti

Yarn Sources

Anzula
740 H St.
Fresno, CA 93721
anzula.com

A Verb for Keeping Warm
6328 San Pablo Ave.
Oakland, CA 94608
(510) 595-8372
averbforkeepingwarm.com

Baah Yarns
(760) 917-4151
baahyarn.com

Berroco
1 Tupperware Dr.
Suite 4
N. Smithfield, RI 02896-6815
(401) 769-1212
berroco.com

Brooklyn Tweed
brooklyntweed.com

Dragonfly Fibers
4104 Howard Ave.
Kensington, MD 20895
(301) 312-6883
dragonflyfibers.com

Dream in Color
dreamincoloryarn.com

Hazel Knits
PO Box 28921
Seattle, WA 98118
hazelknits.com

Jamieson & Smith Shetland
shetlandwoolbrokers.co.uk

Malabrigo
(786) 866-6187
malabrigoyarn.com

The Plucky Knitter
thepluckyknitter.com

Quince & Co.
quinceandco.com

Stitch Sprouts
(877) 781-2042
stitchsprouts.com

Stonehedge Fiber Mill
2246 Pesek Rd.
East Jordan, MI 49727
(231) 536-2779
stonehedgefibermill.com

Sweet Fiber Yarns
sweetfiberyarns.com

Tanis Fiber Arts
tanisfiberarts.com

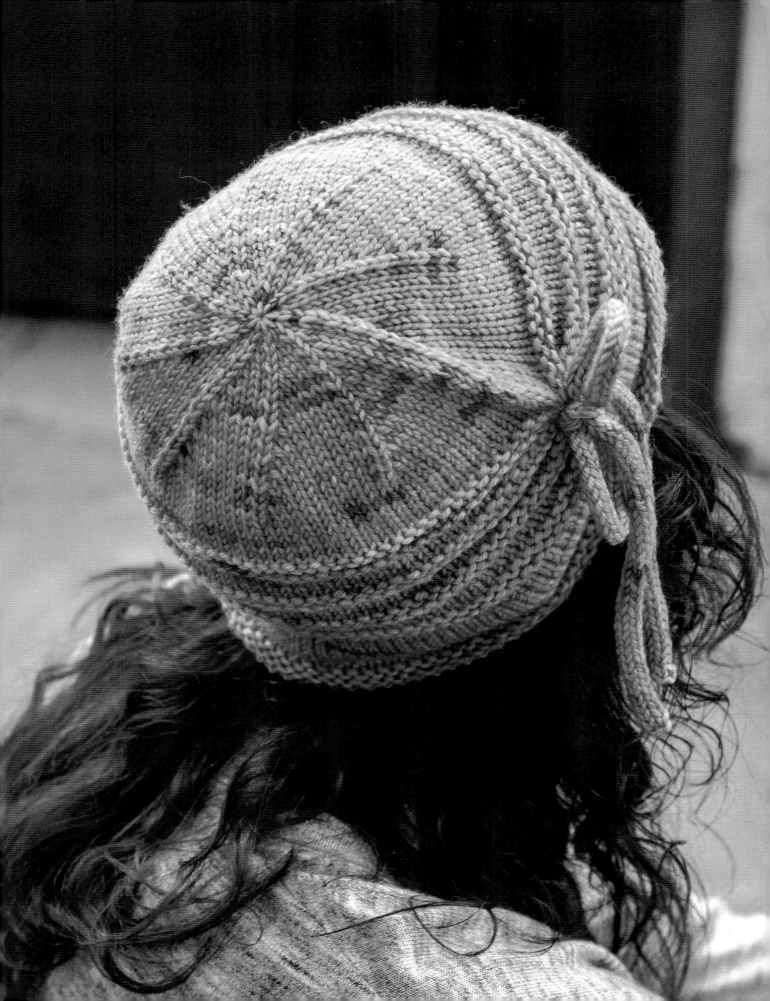

Index

fw

a content + ecommerce company

fwcommunity.com

20 19 18 17 16 5 4 3 2 1

Distributed in Canada by Fraser Direct
100 Armstrong Avenue
Georgetown, ON, Canada L7G 5S4
Tel: (905) 877-4411

Distributed in the U.K. and Europe by
F&W MEDIA INTERNATIONAL
Brunel House, Newton Abbot, Devon, TQ12 4PU, England
Tel: (+44) 1626 323200, Fax: (+44) 1626 323319
E-mail: enquiries@fwmedia.com

SRN: 16KN06
ISBN-13: 978-1-63250-221-6

Curated by Kerry Bogert
Editor: Michelle Bredeson
Technical Editor: Minh-Huyen Nguyen
Cover Designer: Frank Rivera
Interior Designer: Corrie Schaffeld
Photo Shoot Direction: Bekah Thrasher
Photographer: Donald Scott
Stylist: Tina Gill
Hair & Makeup: Kathy MacKay

We make every effort to ensure the accuracy of our patterns, but errors sometimes occur. See knittingdaily.com/errata for corrections.

Metric Conversion Chart

To convert:	To:	Multiply By:
Inches	Centimeters	2.54
Centimeters	Inches	0.4
Feet	Centimeters	30.5
Centimeters	Feet	0.03
Yards	Meters	0.9
Meters	Yards	1.1

Got Hats?
(and Scarves, Cowls, and Mittens?)